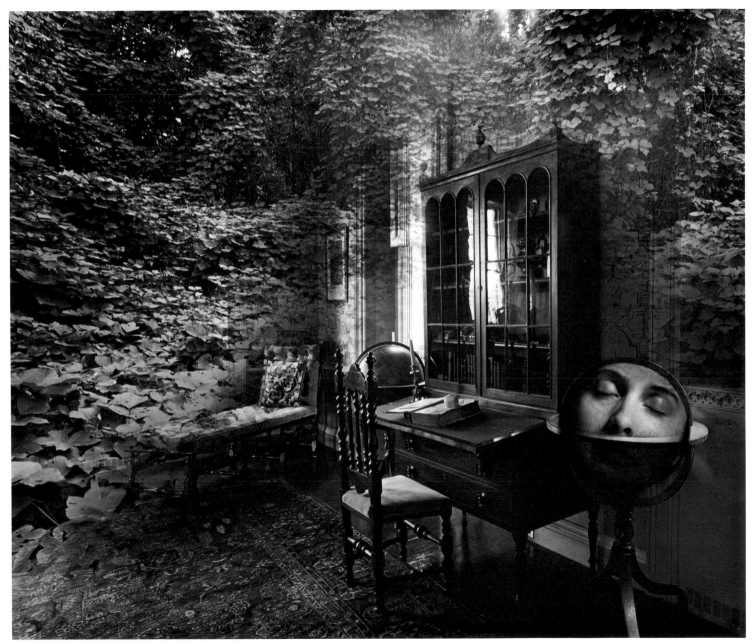

1982

UELSMANN

PROCESS AND PERCEPTION

Photographs and Commentary
by Jerry N. Uelsmann

Essay by John Ames

UNIVERSITY PRESSES OF FLORIDA
University of Florida Press / Gainesville

06 05 04 03 02 01 10 9 8 7 6 5

Library of Congress Cataloging in Publication Data
Uelsmann, Jerry, 1934–
Uelsmann: process and perception.
1. Photography, Composite. 2. Uelsmann, Jerry,
1034–, I. Title. II. Title: Process and perception.
TR685.U37 1985 770'.92'4 85-6035
ISBN 0-8130-0830- (alk. paper)

University Presses of Florida is the central agency for scholarly publishing of the State of
Florida's university system, producing books selected for publication by the faculty editorial
committees of Florida's nine public universities: Florida A & M University (Tallahassee),
Florida Atlantic University (Boca Raton), Florida International University (Miami), Florida
State University (Tallahassee), University of Central Florida (Orlando), University of Florida
(Gainesville), University of North Florida (Jacksonville), University of South Florida
(Tampa), University of West Florida (Pensacola).

University Presses of Florida
15 NW 15th Street
Gainesville, FL 32611
http:\\www.upf.com

I would like to acknowledge the catalytic presence of Deidre Bryan in the making of this
book; her enthusiasm brought the project into focus, and her editorial skills made it a
reality. – *J. N. U.*

CONTENTS

To the spirit of play in all of us

TECHNIQUES

For me the darkroom functions as a visual research laboratory. Usually I run through fifty sheets of paper during a darkroom day. I always hope that at the end of the day, I will have produced one or two images that I care about. I make a small edition of each of these, usually six prints. Over the years I have discovered that approximately 10 percent of my finished images survive. This means that out of a year's work, during which I produce approximately 150 images, about fifteen of them have a lasting value for me.

In my darkroom I have eight enlargers. Rarely do I use that many, but it is helpful to have more than one enlarger to execute multiple printing techniques. All of the images in this section are shown with their component parts on the facing page. Printing these images required the use of several enlargers, one negative in each enlarger. Sometimes I block immediately below the enlarger lens to keep part of the paper white so that it can receive a second or third image. Other times I mask with black paper at the easel on the base of the enlarger; this works when you have a hard-edged area to transfer from one part of the image into another part. I print on the paper in one enlarger, then move it to a second enlarger for the second part of an image, and if necessary to a third or fourth; finally, I process the print normally. In some instances I photograph objects and figures on a plain white background or a light table; this makes it easier for me to print those elements into light areas on the print. I use easels that are very stable and on occasion I tape them to the baseboard of the enlarger, once I have the proper alignment. I do lots of testing, for correct exposure and for correct blending of the separate elements, before I attempt to make a finished print.

When I look at my contact sheets I try to find clues to things that may work, clipping possible combinations together as I flounder. I sometimes make little sketches and then begin by trying to build the image that was initially perceived at the point of making the sketch. When I get an idea for a variation, at any point in the process, I usually change direction and try the new idea. I believe that almost anything you can think of is worth trying. It is difficult to make a qualitative judgment in the initial stages of the creative process.

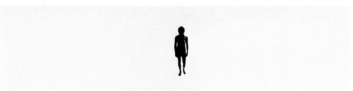

The kudzu house image involved four different negatives. On the negative of the kudzu vines, I blocked below the enlarger lens, creating a soft edge so that the bottom half faded off into white.

The building, in a second enlarger, was blocked below the lens at both the top and the bottom to allow it to fade into white paper, above and below the building. Because the windows and the door area appeared dark, I knew they would leave their imprint on top of the kudzu.

The water in the foreground, in another enlarger, was blocked so that it faded off into white on the top half.

The small figure was photographed against a white background and printed in the doorway area through a vignetter.

4

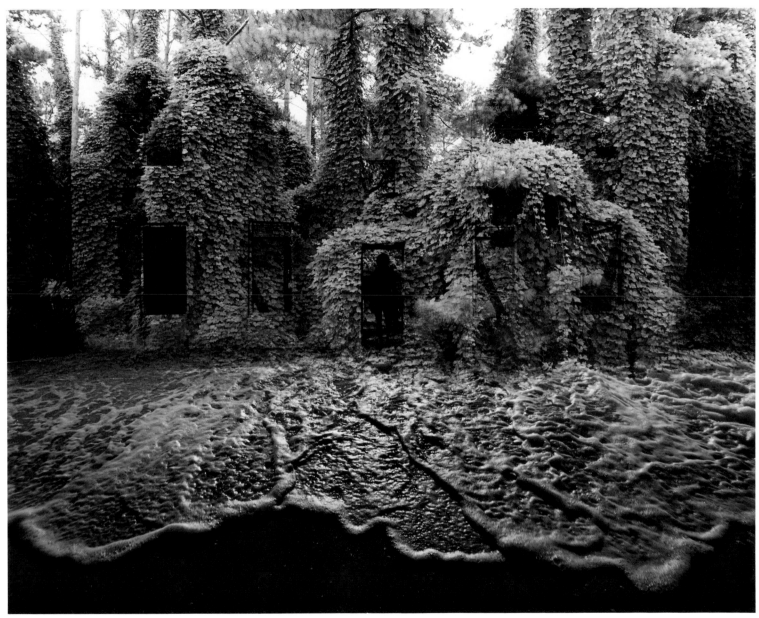

1982

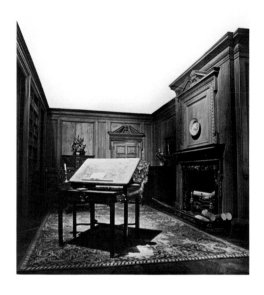

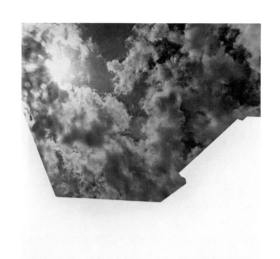

For this image, the negative with the room interior was in one enlarger; with black paper I masked at the easel, following the cornice of the top of the wall around the room.

On the sky negative, in a second enlarger, I masked at the easel the area where the room would appear, allowing for a tiny overlap with the cornice of the wall.

In a third enlarger was a negative of a man walking on the beach; the enlarger was lowered to print the figure very small and the negative was vignetted to keep the white beach as light as possible. I moved the paper, as I do in all multiple prints, from enlarger to enlarger for each exposure.

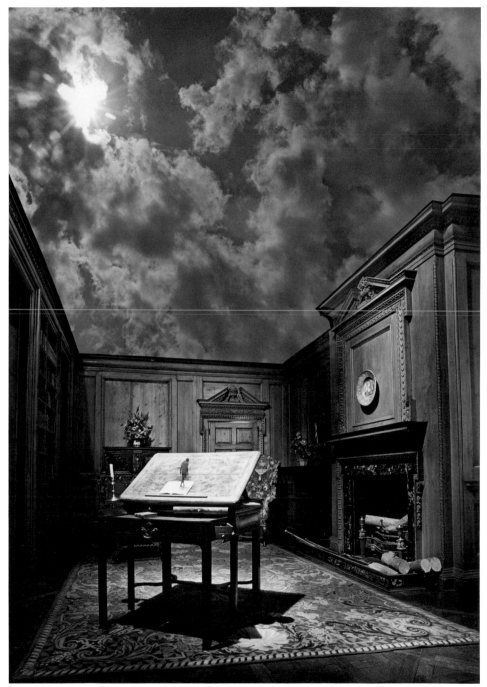

1976

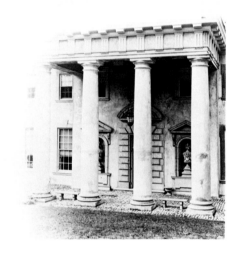

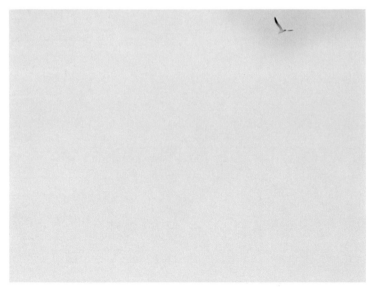

The negative with the wall and the tree in the corner was in one enlarger, and it covers the entire print. The area of the wall where the sun was hitting is very light and thus able to receive a second image.

In the second negative, the building happened to be photographed at the same angle as the wall; in another enlarger, it was blocked below the enlarger lens so that it would fade off into light near the shadow area of the tree.

In a third enlarger I placed a negative of a bird simply to add another small element to the white sky area.

1981

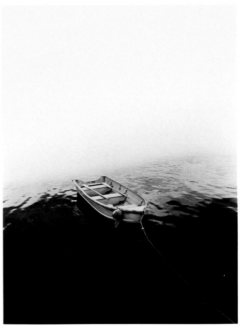

This print involved two negatives plus a metal template with a die-cut hole in it, used as a third negative in the enlarger. In one enlarger I placed the boat negative and blocked below the enlarger lens with a piece of cardboard so that it faded off into white. In a second enlarger, the sky negative was blocked below the lens so it also faded off with a soft edge into light.

In a third enlarger the metal template with the hole was placed in the negative carrier; below the enlarger lens I blocked with a piece of cardboard in a curved shape that created a soft edge in the interior of the sphere. When it was printed on top of the sky area it introduced the sphere-like shape in the sky.

14

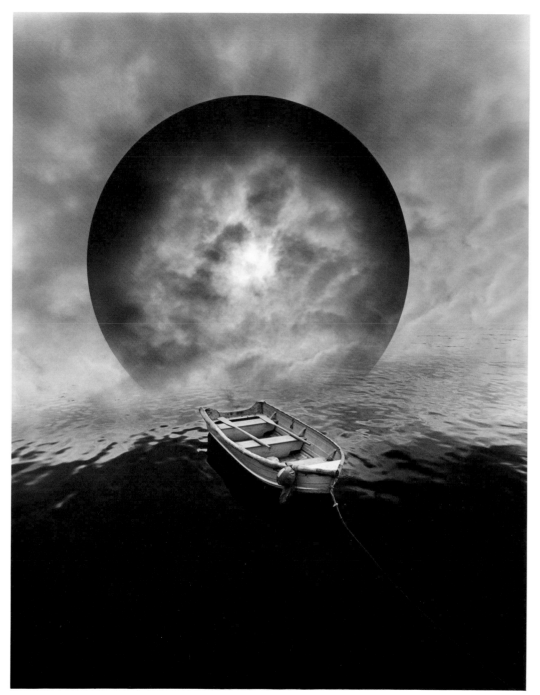

1982

For this image, I used four enlargers, three negatives, and the metal template with a hole cut in it. I blocked the sky negative below the enlarger lens to have a soft edge fading off into white.

In a second enlarger, the water negative with the footprints on the beach was blocked on the opposite side so it would also fade into white.

The woman was photographed on a white background; that negative, in a third enlarger, was blocked below the lens so that the lower torso and legs of the figure faded off into light.

In the fourth enlarger, the metal template with the die-cut hole was placed in the negative carrier; below the enlarger lens a curved piece of cardboard was used to block the interior of the circle, creating a soft edge on the inside.

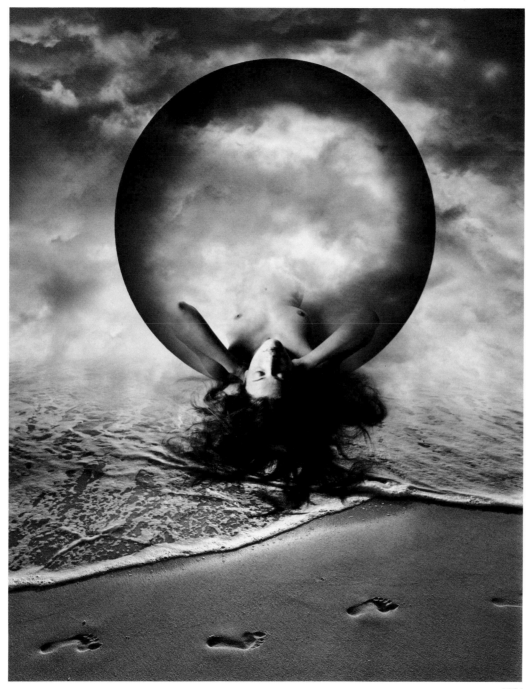

1984

DARKROOM DAY

After overcoming my initial reservations, I decided to illustrate the process of achieving a finished photograph by showing every print that led, step by step, to the end product of a day's work. Most photographers feel a natural aversion to the idea of allowing anyone to see, much less publish, photographs that are unfinished, images that didn't seem to work. I consider two of the nineteen photographs in the following series to be finished and maybe ready for an audience. My decision to show all of them was influenced by my belief that the artist usually doesn't have a privileged sensibility, in the sense of effortless inspiration—therefore, refusing to allow my embryonic work to be seen would distort the reality of the creative process. I work very hard as an image-maker, and the images never come to me full-blown. There is always a lot of internal dialogue and trial and error. The recognition of questions is more important to me than discovering the answers. The images keep raising questions that I answer as best I can, usually provoking new questions, both visual and ideological.

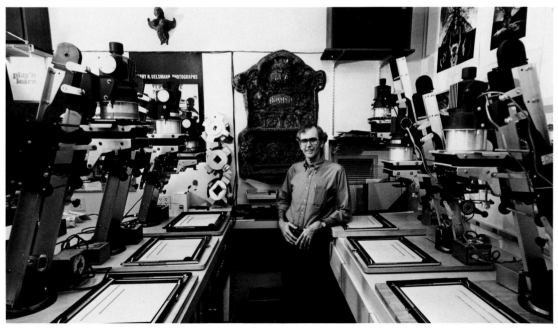

Photo by Jeffrey Lotz

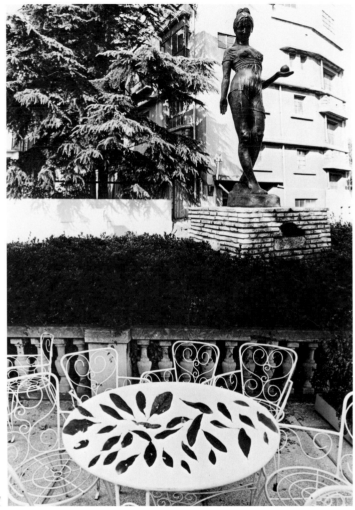

1

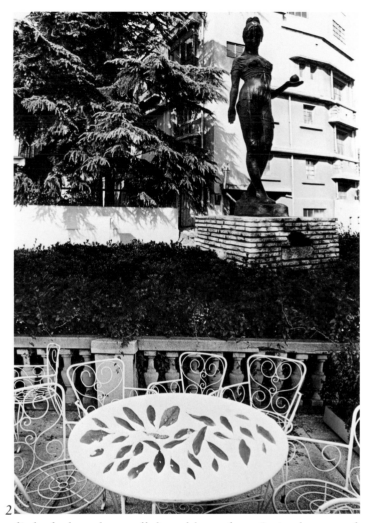

2

On this particular morning, I looked at my contact sheets to try to come up with some ideas of things that might work, different images that might blend together in some interesting manner. After a frustrating hour, the only idea that seemed viable was this image in picture number one, with the table in the foreground and in the background a statue of a woman holding a piece of fruit. I decided that I could print something on top of the table. The print involved three enlargers—one negative in each enlarger. In the first print, the leaves on the table looked a little dark and ran off the table surface. So in the second print I adjusted the appropriate enlarger and made the leaves smaller so they were contained on the table, and I also made them lighter.

I also improved the blending between the foreground and the background. (The location of the foreground is in Zagreb, Yugoslavia; the background is in Tokyo.) The point where the foliage was blending together was too dark in the first print. In each stage I try to make as many technical corrections as I can.

22

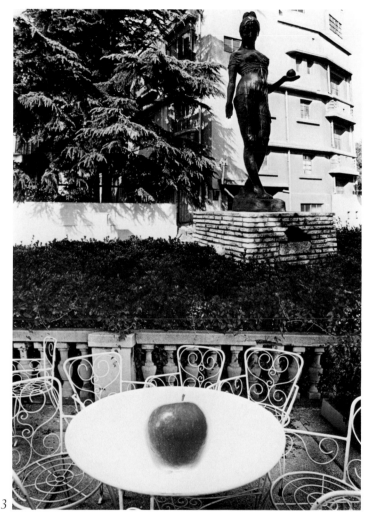

3

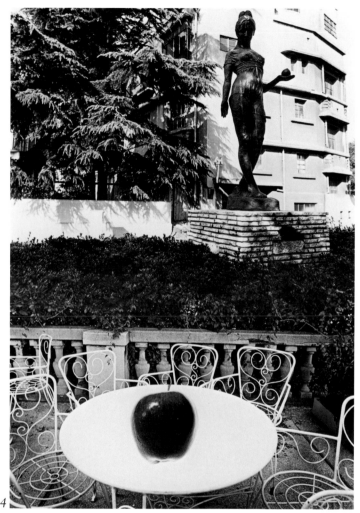

4

I don't have a hidden agenda when I begin. I'm trying to create something that's visually stimulating, exciting, that has never been done before but has some visual cohesiveness for me, has its own sort of life. I must say that in this instance, I began questioning the image at this point—was it a meaningful image in whatever terms I could bring to bear on it.

After deciding that the leaves did not work well, I noticed the fruit in the statue's hand and remembered that I had recently photographed an apple on a light table. The apple had been photographed on a light table to produce a pure white background; this enabled me to introduce it on the white table in the foreground in print three. After doing so I realized that the apple might work better if it were a little higher and I thought it should also be a little darker, resulting in the next version, print four; but making it higher caused the stem to run off the edge of the table.

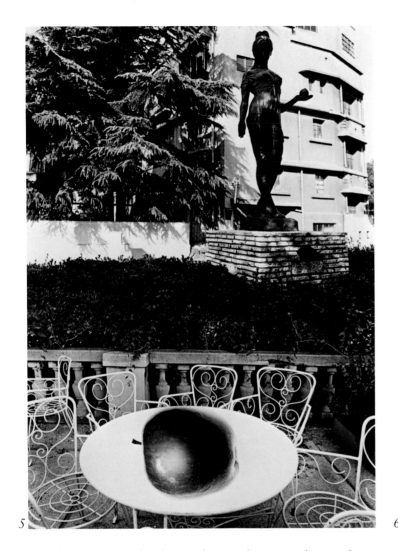

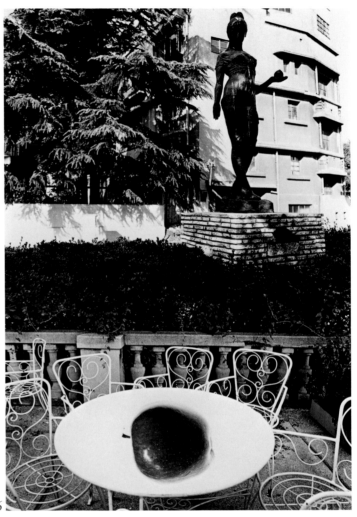

I decided to make the apple even larger and turned it on its side; at that point, it was still running off the top edge of the table.

Next I made it a little smaller and lower, but I was still unhappy with the way the image affected me.

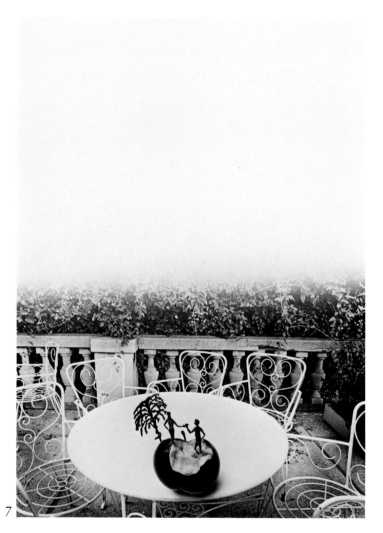

7

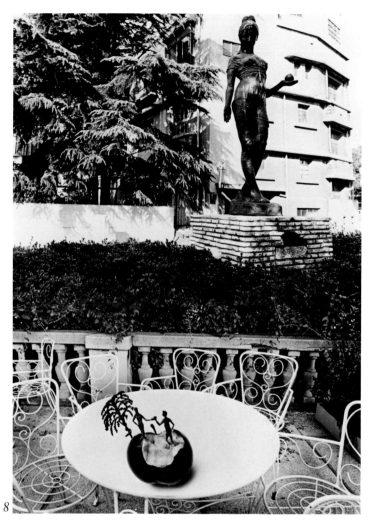

8

I noticed that on the same contact sheet there were some photographs of an apple that I had taken a bite out of and then had pushed into it these little statues of Adam and Eve. I printed that on the table. Now at this point, image seven, I was getting so frustrated that I forgot to print the top half of the image, so it just faded off into nothing.

Finally (in print eight) I resolved, as best as I could, but not to my satisfaction, the image with the bite out of the apple on the table as the foreground and the statue as the background.

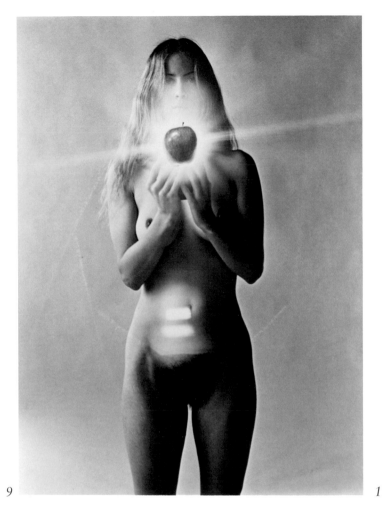

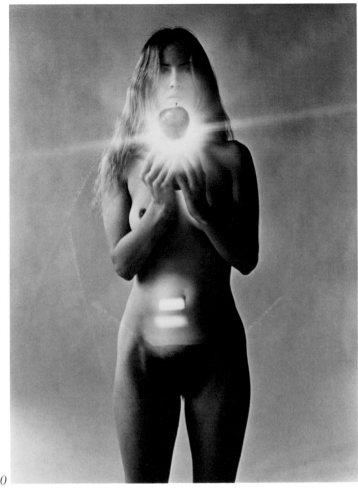

9

10

By this time it was 1:00. I was ready for a little lunch, and I wanted to check in to see what was happening on *All My Children*. During lunch break, for reasons that I cannot explain, I remembered that I had recently photographed a model while she fired a flash back at the camera during exposure. When I came back into the darkroom after lunch, I dug out one of the apple negatives and printed the apple in the area where the flash was fired back at the camera. I immediately responded to this image much more emotionally, and felt it had far greater potential than the previous one. I then noticed that the apple was a little low in relation to the light source and also a little bit dark. So in image ten, I raised the apple and made it a little bit lighter so that the glow appeared to be coming from the apple itself.

At this point, I remembered that I had received a lot of criticism for centering images—that my work had a very strong central bias, and rarely were there very inventive

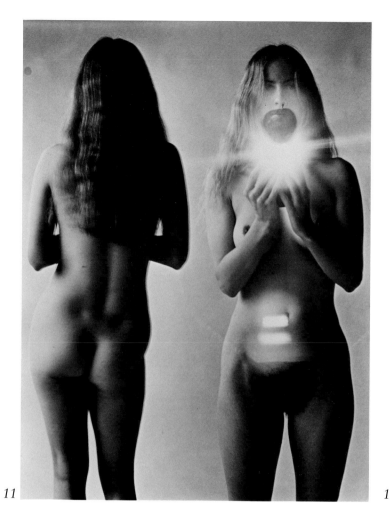

11

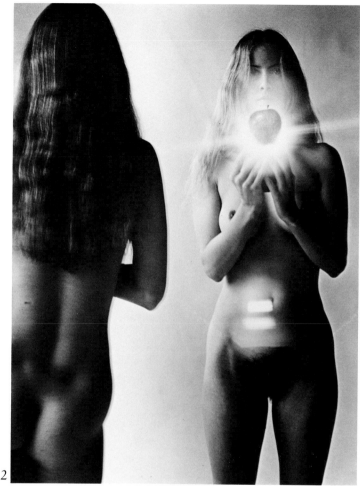

12

compositional things happening. So I thought that maybe if I moved the figure to the side of the image, I could introduce the figure in some other form on the opposite side. In doing so, I did not adjust the apple negative properly, and, as you can see in image eleven, the apple runs up over the mouth and near the nose. I had introduced the back of the figure on the opposite side, and they were both on the same scale. As I looked at this I was bothered both by a mark on the negative and by the fact that, both

figures being on the same scale, there wasn't any sort of self-confrontation occurring within the image.

It then occurred to me to make the back view of the figure much larger, hoping to get some interaction between the two figures. Once I had done so, I decided that, technically, because the back-view figure had moved during the original exposure, it was unacceptable and I would have to resolve the image some other way.

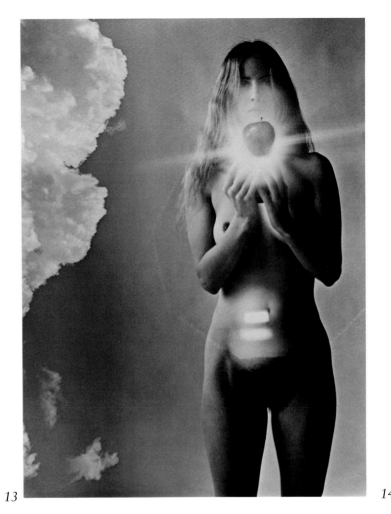

13

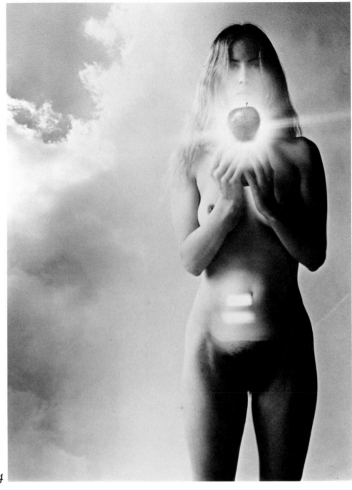

14

I had gradually become conscious of the fact that the background was producing a sort of grey tone, and it reminded me of sky. I got out some of my sky negatives and introduced them along the side. In the first one, image thirteen, I knew that the sky would work but thought a better cloud formation would be more effective. So I

tried another cloud negative (image fourteen) and thought it was better than the first.

Something was bothering me at this point; I had just come back from Japan, where I had learned that they didn't allow pubic hair to appear in published pictures. Although I wasn't planning to use the picture in Japan,

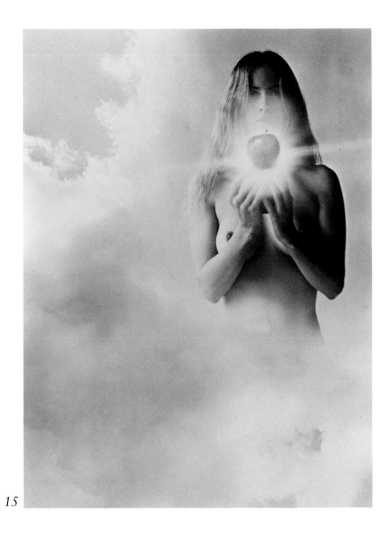

15

knowing about this just made me extra sensitive to that issue, together with the fact that I was becoming sensitive to feminist issues. I thought, well, is there a way I could eliminate the pubic hair, and I decided that I could. So in image fifteen, I eliminated the bottom of the figure, and I liked the way the figure sort of floated within the clouds.

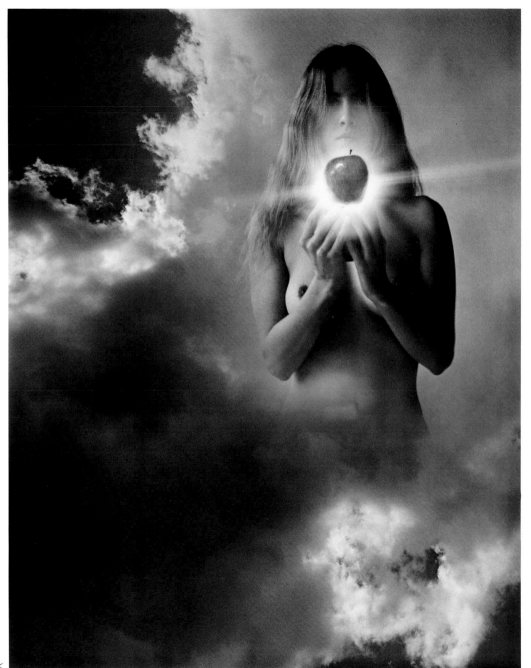

1981

The only way that I thought I could improve upon this version was simply to print the whole thing darker, with the exception of the apple—to let the brightest spot within the image be the light source behind the apple. Image sixteen, then, was the version that I decided was resolved. Once I resolve an image I try to do a small edition, usually six prints, so I printed them up.

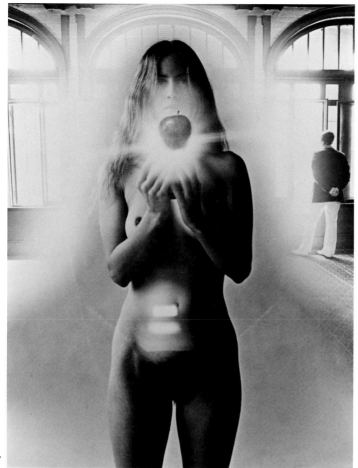

17

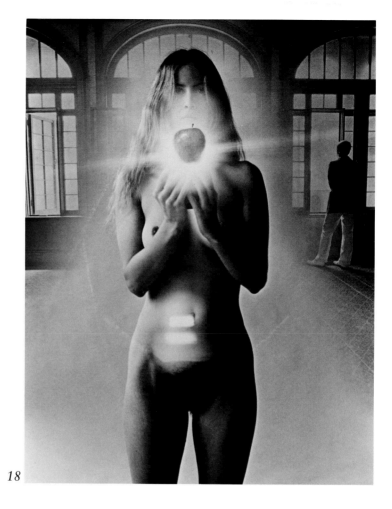

18

It was late in the afternoon, and I was about to conclude for the day; in putting my negatives away, I saw a contact sheet that had a negative of an interior environment, and it occurred to me that maybe I could introduce the figure in such an environment. So I centered the figure again on the page and tried to blend in the background, hoping to create a believable environment. There were some immediate technical problems that I thought and thought about but could not resolve, concerning the blending of the plain background of the figure into the detail of the interior. Suddenly it occurred to me that I was trying too hard to make it a believable situation, that instead of having a normal tonal range for the background negative I should just let it become grey by fading into the background of the figure negative. I then let the background become a grey tone, so it was less believable, but it was still there.

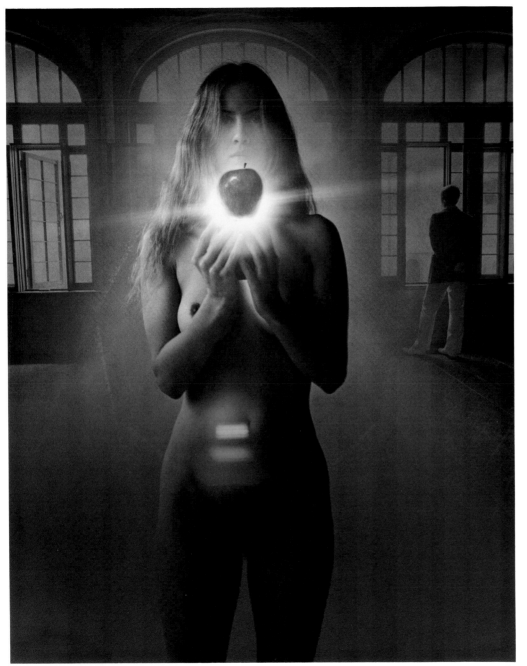

1981

At this point, I remembered the pubic hair problem, but since there was no way I could eliminate it in this case, I simply made the image much darker, particularly in the bottom portion. I immediately liked this one best, and image nineteen became a second final version.

By this time, I was extremely tired because you have to stand through the entire process. I printed another small edition. Because I concentrate so intensely on detail while I'm working, it wasn't really until the next morning that I recognized the obvious iconographic implications of the image that are so blatantly there. It seems impossible, in retrospect, that I didn't plan to do an Eve photograph. But at the time I was working the idea didn't enter my conscious thought.

PORTFOLIO
1980 – 1985

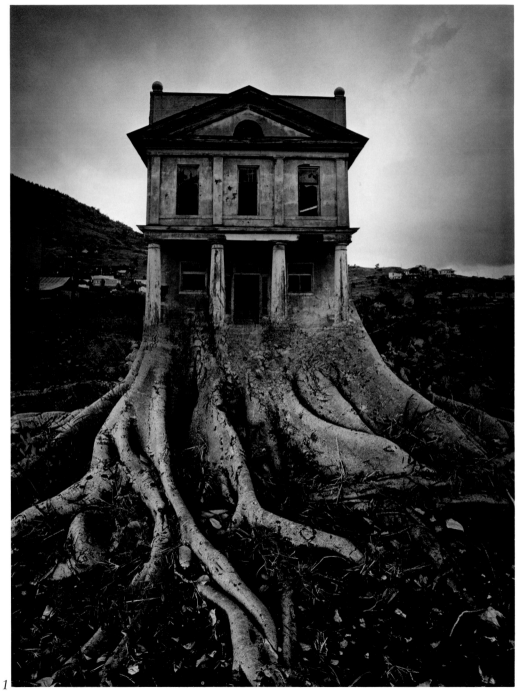

1

1982

RECONCILIATIONS

by John Ames
I once stood behind a couple in a bookstore as they leafed through a volume of Jerry Uelsmann's photographs.

"These are fantastic," said the girl.

"Yeah," said the boy. "Uelsmann must be some kind of saint."

I wondered if he'd feel the same if he saw the Uelsmann that I occasionally did at my racquetball club. He was pointed out to me one day, a gangling man with his elbows on his knees, breathing heavily and sporting an artful drop of sweat hanging from the end of his nose. It certainly wasn't the conventional image of a saint, but I liked it because no amount of earthly sweating could ever compromise the mystical impact of Uelsmann's photographs. In fact, the contrast between his locker-room demeanor and the obvious spirituality of his art seems perfectly in keeping with Uelsmann's great subject: the reconciliation of opposites.

For most of us, the world is a mix of compatible and incompatible elements; we choose a side and take up arms against the things in opposition to us. Often, though, we feel a desire to be done with the anxieties of combat, and we tell ourselves that we could be at peace if only the world were different. Uelsmann shows us an altered world and, in the showing, suggests that the pain of separation may not be so much inherent in the world as it is inherent in the way we see the world.

Ironically, transcendent art such as Uelsmann's is created by people who are themselves not quite transcendent, people who yearn for an ideal but have not yet plunged permanently into the void. Their art is a tapestry of longing, invaluable because it comes to us from fellow human beings. Their vision may be superior to ours, but they are nonetheless immersed in our world. Their longing stirs us because the desire for reconciliation is at the heart of life. Every time lovers join, that desire is celebrated anew, and every time Uelsmann makes a photograph, the celebration continues.

Because Uelsmann's images strike so deep a chord, many people

feel an impulse to analyze them. His photographs are often pored over for symbolic content, but counting archetypes or phallic symbols in his work only scratches the surface. Symbols are not essential in his photographs any more than the detailing on a building is essential. It is the substructure of a building that gives it shape and provides the form onto which the more obvious features are applied; if these features are dramatic and moving, then they are indebted to a strength not so obvious.

In Uelsmann's photographs, the substructure is polarity. Of course, the same might be said of all photographs, since they exist through the interplay of light and dark. Uelsmann's special talent is in making polarity visible and new. His ability to juxtapose objects that are seemingly mutually exclusive, and to create plausible connections between them, helps the viewer to overcome the mind's tendency to categorize and separate, and this is a first step toward reducing the apartness that one feels from one's environment. In this Uelsmann is aided by photography's reputation as an unbiased recorder of reality; so, even though his photographs represent a meticulous distortion of ordinary reality, they still carry the impact of reality, and this is an impact denied to other artists, such as Magritte, who have created similar images in other mediums.

Because his imagination is augmented by a great technical expertise, Uelsmann is able to link opposites in ways that seem credible. In Figure 1, a two-story stone house is rooted in the ground; the organic and the inorganic are joined; the natural and the artificial are reconciled through the juncture that he has created. The observer is forced to consider the photograph's implication that both the natural and the artificial spring from the same source. Ultimately, there is no distinction between them. This implication exists in all of Uelsmann's photographs, in spite of their variety. Figure 2, which has a composition similar to that of Figure 1, achieves the same type of connection using different elements. In the lower portion of the photograph are objects of density and mass. They rest on an equally substantial slide. The observer's eye is led upward by the lines of the slide and is left in the vaporous space of

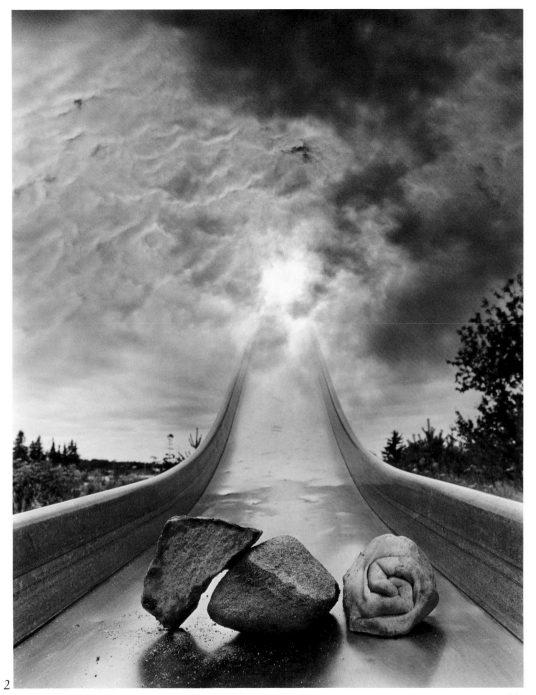

2

1981

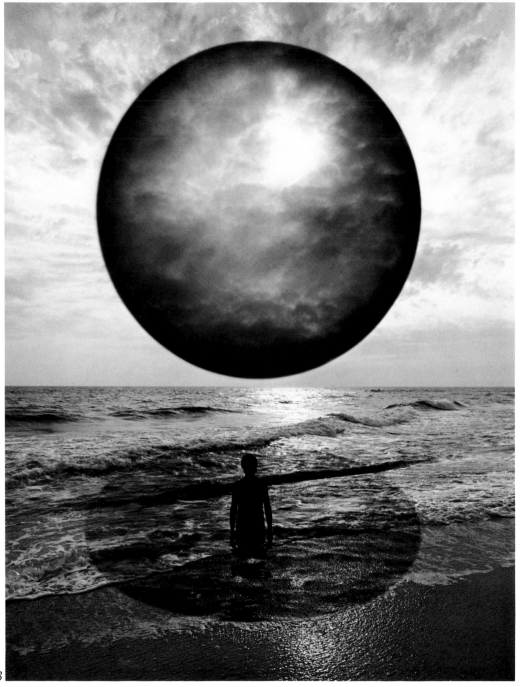

3

1982

the sky. In this picture, high and low, solidity and space are seen as connected, and, though the eye is drawn upward, the presence of the slide suggests that the transit could just as easily be from the abstract sky above to the concrete world below.

It is, however, the world of abstraction that holds special interest for Uelsmann. If it were not so, he might have been content with more conventional photography, the type that pays homage to the physical world; but he is fascinated by the unseen factors that complement the realm of the concrete. These factors are represented in his photography by the least physically substantial elements of the material world, such as water, clouds, and light. The concrete is represented by denser substances, such as wood and rock. The photographs suggest a fluid interplay between the abstract and concrete in their varying degrees of visibility.

Uelsmann often uses the device of geometric forms to mediate between the worlds of the concrete and the abstract. Such forms are the imagined ideal made visible, and he uses them to show the impact of the abstract on the concrete world. In Figure 3, a sphere dominates the sky and casts a shadow on a man standing knee-deep in the sand at surf's edge. The geometric figure has two effects. It calls attention to the relationship between the man and his environment (he stands at the juncture of earth, air, and water), and it also keeps him from experiencing the light from above. So, while the sphere captures the man in the photograph, impeding his movement upward, it also helps the observer gain a new perspective on the world.

The double-edged aspect of these geometric forms is suggested in many of Uelsmann's photographs. In Figure 4, the child strides away from the once-living butterflies, neatly categorized in their square boxes. He is heading toward a door which penetrates a geometrically balanced architecture. Outside, he will confront a new reality, one that lies at an opposite pole. Not only is the butterfly outside uncaptured and presumably alive, it is also a photographic negative. It would be tempting to conclude that Uelsmann judges harshly the well-balanced organization

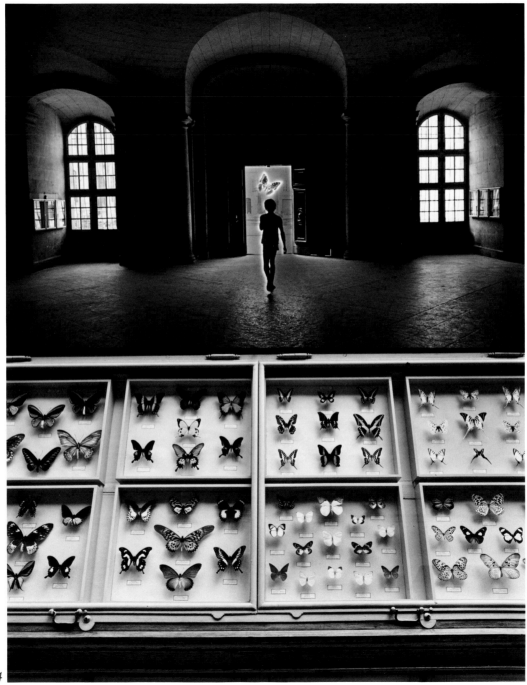

4

1983

that the child is leaving. On the contrary, Uelsmann understands that all realization, all new perspectives arise out of contrast. In Figures 5 and 6, it is the very fact that the elements of nature are reinvented within the geometric forms that gives the photographs impact. In Figure 5, the sky is seen anew, captured within the square of the suitcase. More contrast is added by the fact that the suitcase is lying in a linear environment. In Figure 6, an ordinary seabird is made singular through the addition of a geometric figure. Furthermore, the fact that the cloud shapes on the sphere suggest continents causes yet another interpretation of the creature. It is one bird, true, but it casts a shadow a whole world across. Quite obviously, the demon in one photograph becomes the savior in another, and this is an essential part of Uelsmann's work. His world is not made up of demons and saviors but of polarities, and the real search is not a witch hunt but a search for reconciliation. Out of Uelsmann's productive imagination come the images that invite us to participate in the search. They illustrate polarity in its most formal and its most natural forms.

In Figure 7, a child stands at the center of a formally balanced composition. On the left is brightness and a suggestion of the sea. On the right is darkness and a suggestion of the land. Hovering over the child's head is a perfect sphere. Predictably, the child looks to the left, toward the abstract; that is the direction Uelsmann prefers. After all, Uelsmann is not a saint looking in both directions at once. He is a man creating out of his own preferences, but, through the photograph's balance, showing a profound appreciation for the fact that the child could just as easily look for truth on the right-hand side.

In contrast to the formality of Figure 7, Uelsmann gives us photographs as natural-looking as Figure 8. At first glance this seems a commonplace scene—until, that is, one registers the fact that this boat is resting in a dry landscape. Here is polarity again but in subtler form, and . . . is that a puddle in the road below? And that white object next to it, what is that? Uelsmann shows us that essential matters can be

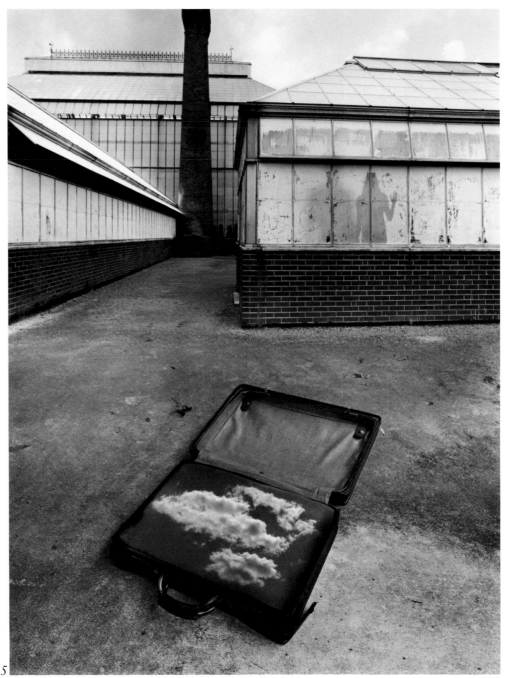

5

1982

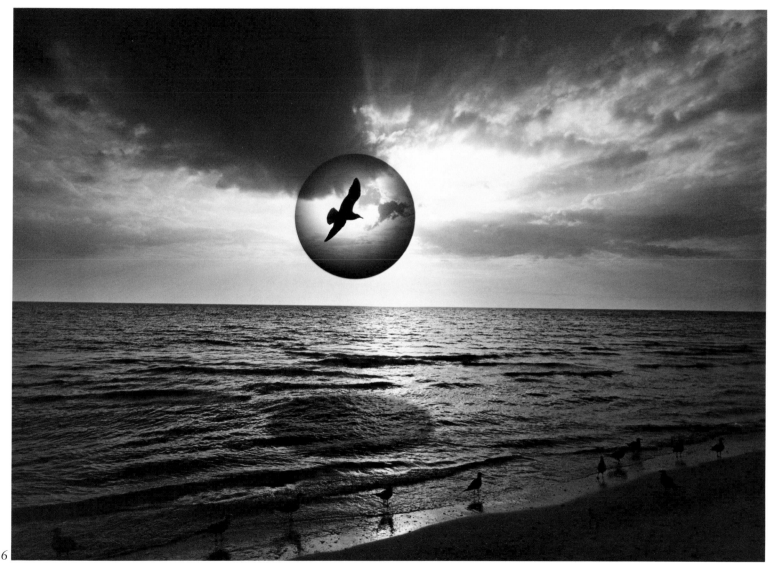

6

1981

perceived in the most natural-seeming circumstances as well as in the most artificial.

Uelsmann's command of both his subject and his medium naturally excites admiration, yet he has expressed the opinion that most artists do not have a privileged sensibility. But, if he is not privileged, then how can he produce these works? The answer seems to be that he has not so much risen above his humanity as he has gotten deeply in touch with it. His comments in part 2 on the creative process are a wonderful illustration of this. Few artists would have the bravery to be so revealing about themselves, because what emerges from the darkroom day is not the story of some god-like intelligence creating with absolute knowledge. (Who could have predicted, for example, that Uelsmann would not immediately recognize a naked woman holding an apple as Eve?) Rather, it is the story of a hard-working man groping toward something that moves him; it is the story of the finite struggling toward the infinite. And toward what understanding does he lead us? The two finished photographs are fine examples.

In one instance, Eve offers us knowledge against the geometric backdrop of a formal hall with a formally dressed man staring into an undifferentiated whiteness. Her soft nakedness contrasts with the rigid formality of the background. In the other photograph, she offers knowledge as a part of the elusive abstraction of the sky. Here she is the more concrete element of contrast, and she seems on her way to being subsumed by the undifferentiated heavens.

Why should anyone complain that this satisfying conclusion was preceded by a concern over the Japanese attitude toward pubic hair? I am inclined to value the pictures more because of that fact. It shows me that the specific and the cosmic are interactive. Well then, you might ask, can this Uelsmann do no wrong in your eyes? The answer to that question is both simple and complex. Ultimately, no. Anything created in a universe of polarities will automatically reflect that truth. But Uelsmann's value to his audience does not lie so much in his message as in his method of presentation. His special consciousness, shaped by his

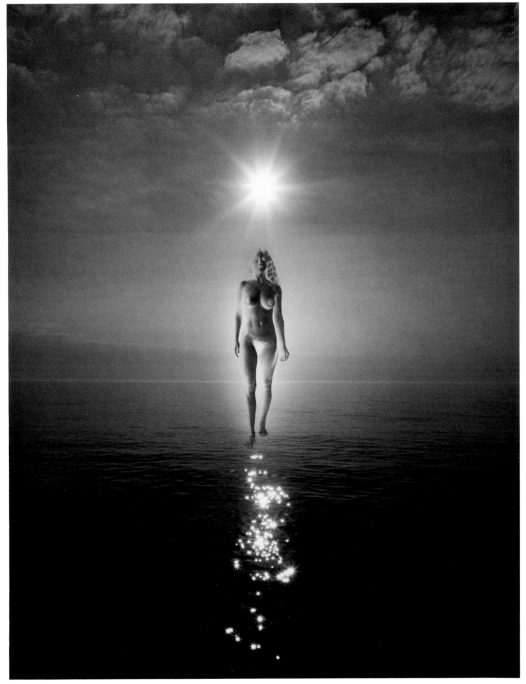

1980

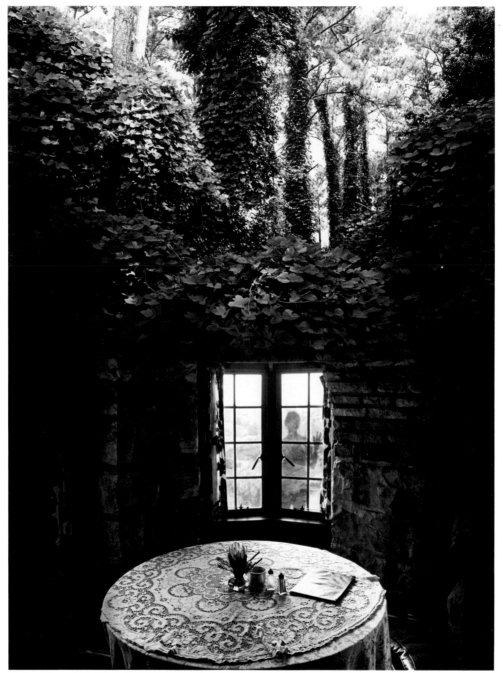

1982

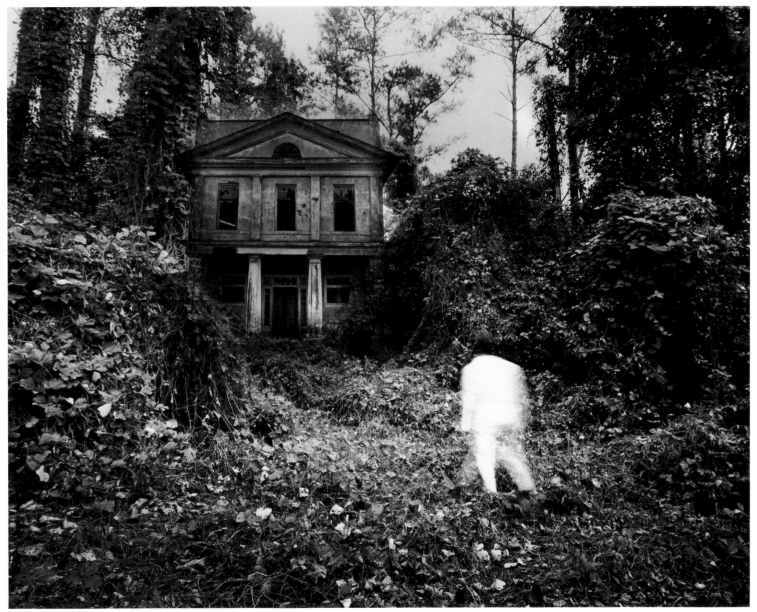

1982

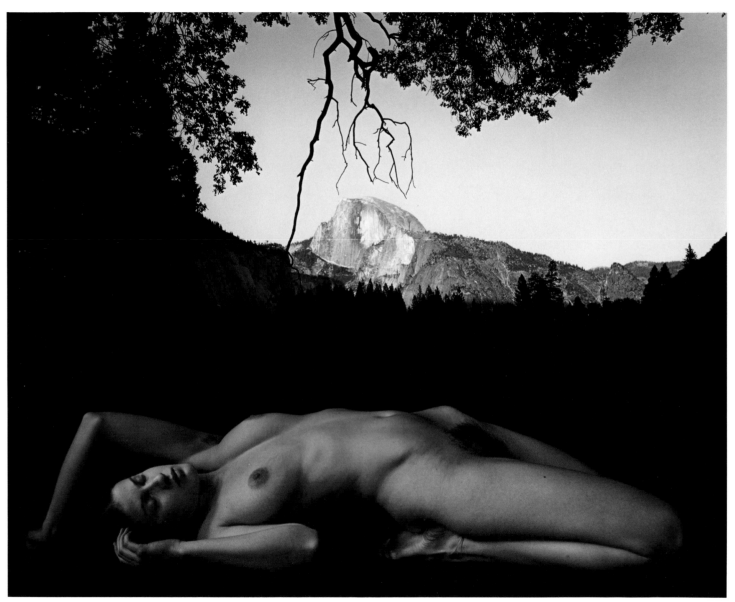

1984

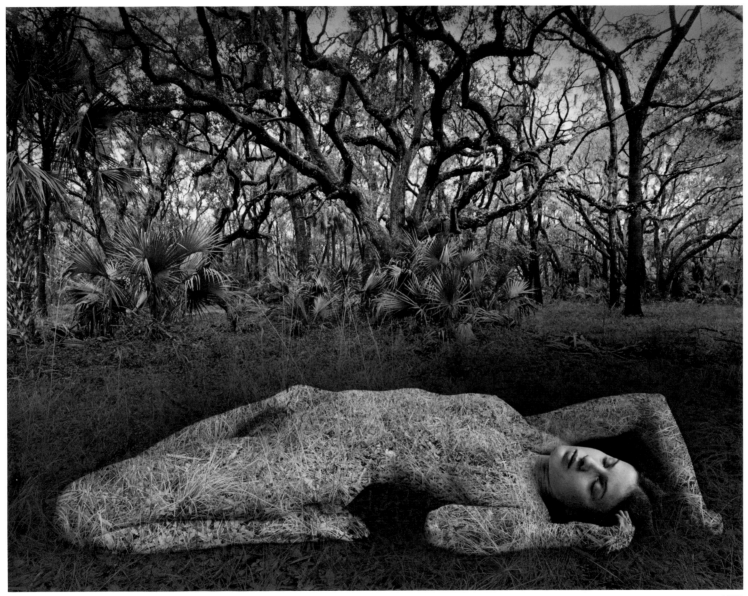

1983

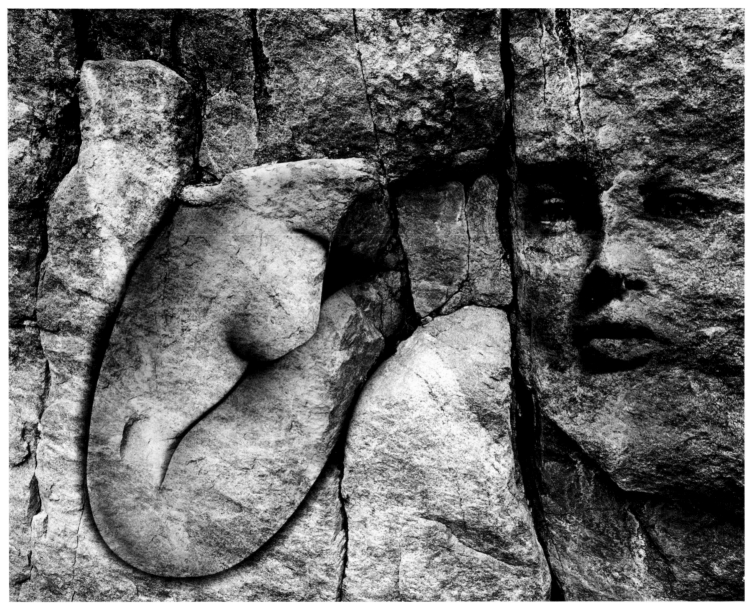

1985

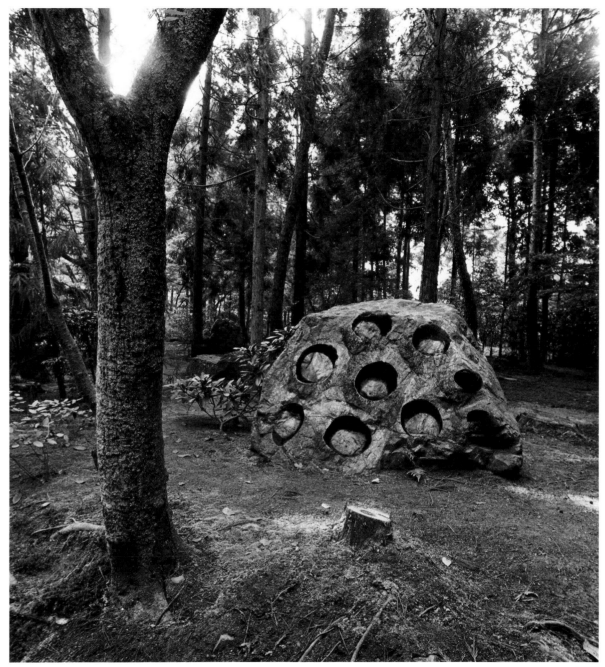

1980

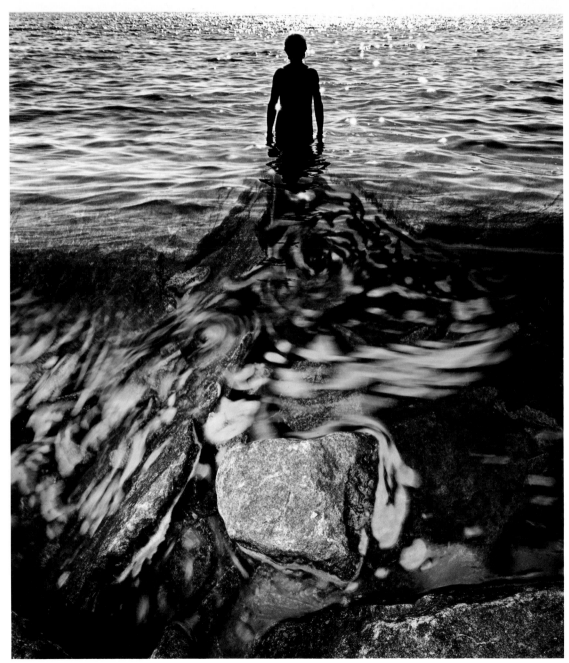

1985

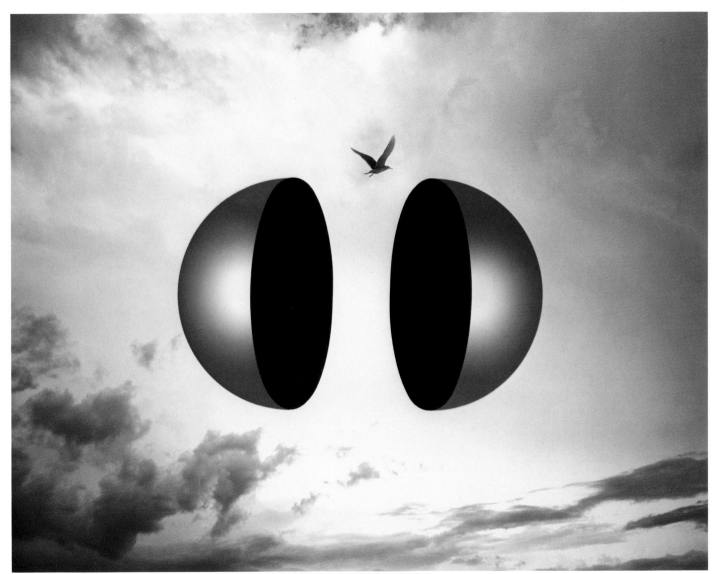

1982

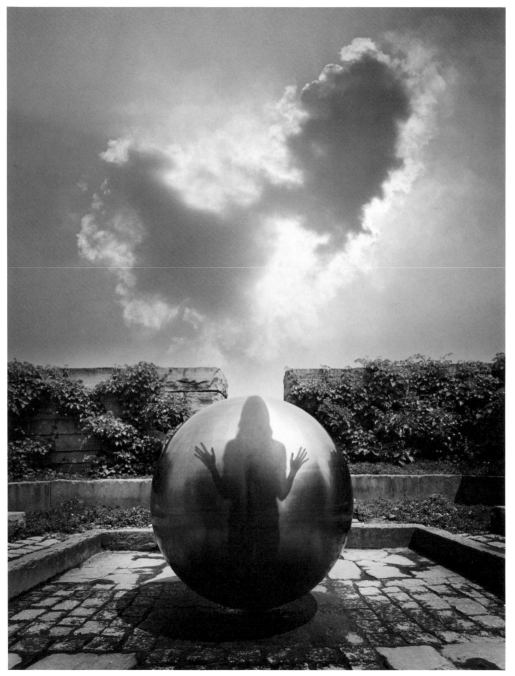

1984

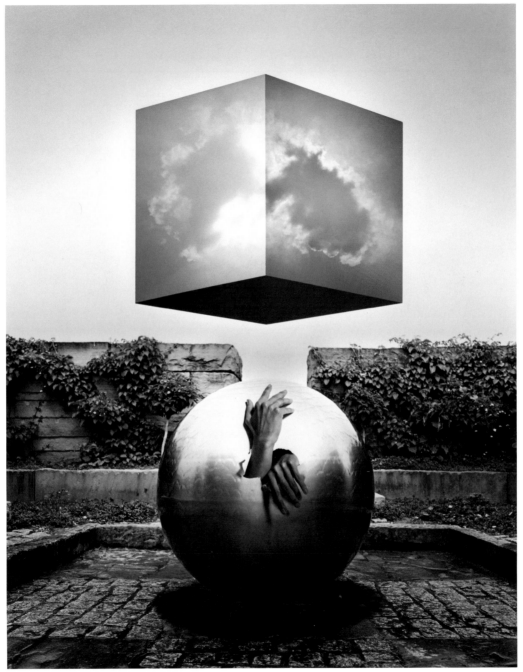

1985

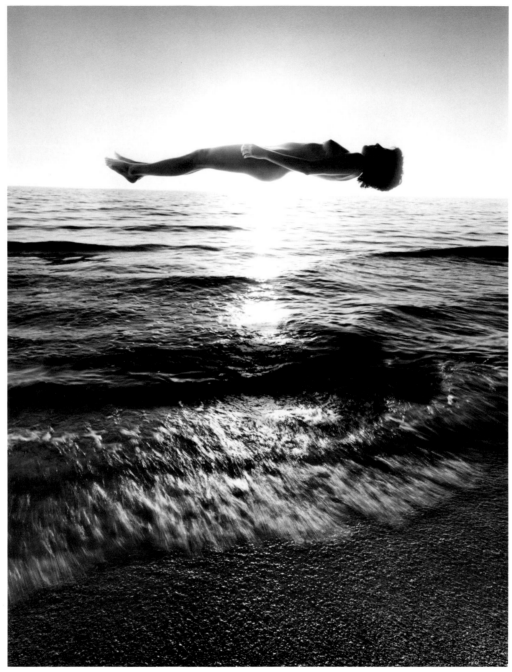

1985

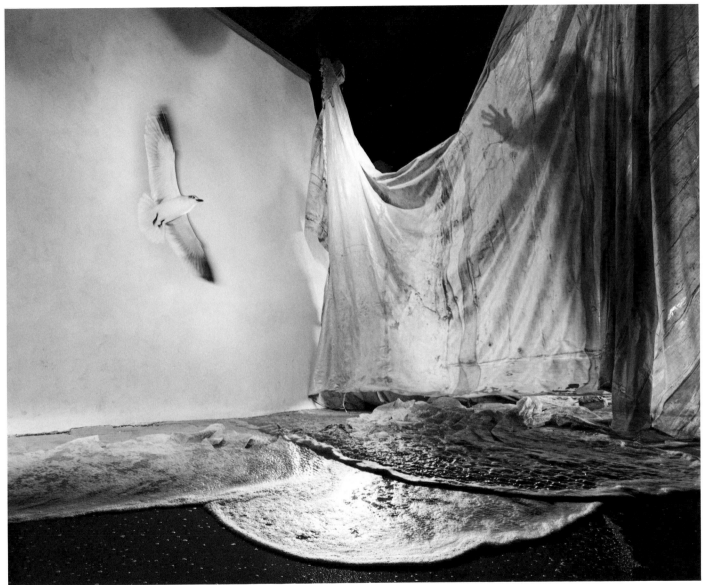

1984

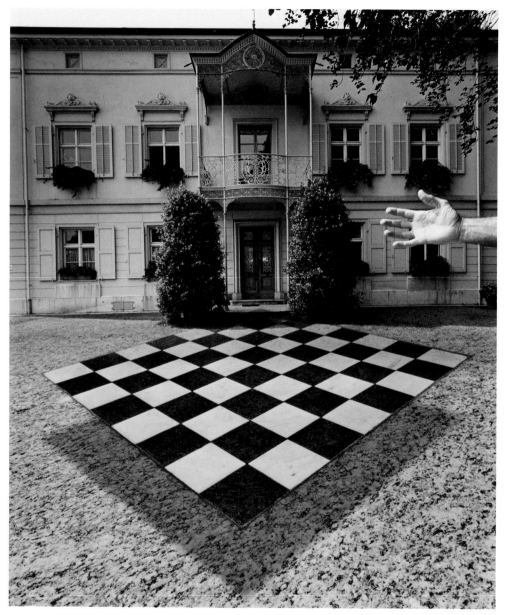

1983

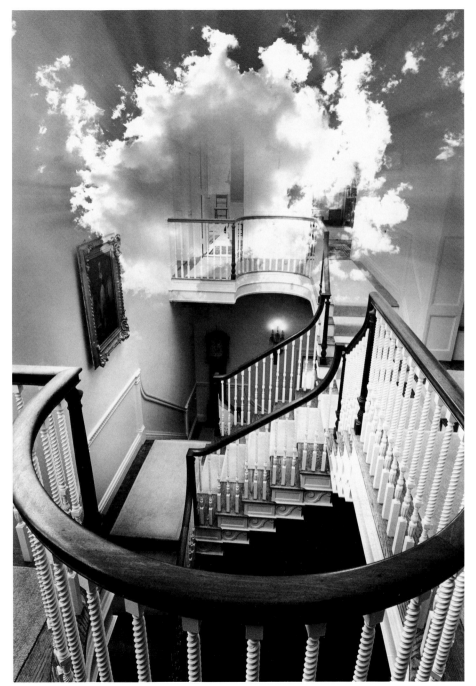

1982

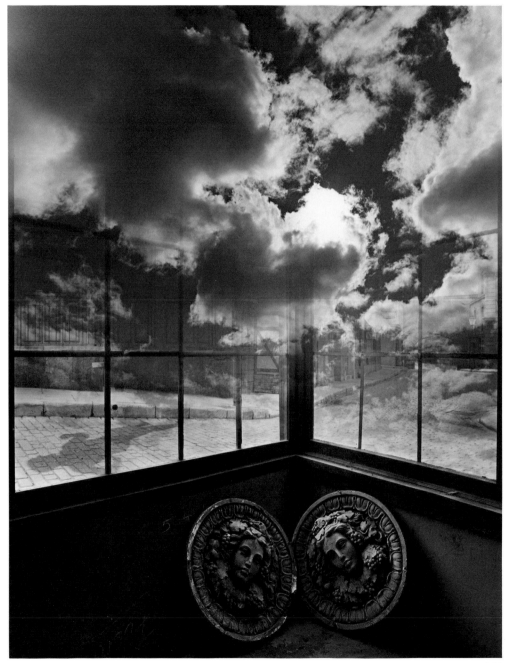

1981

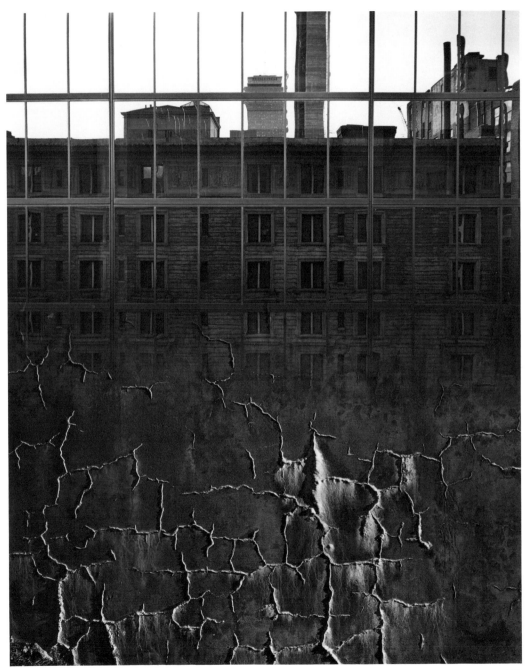

1982

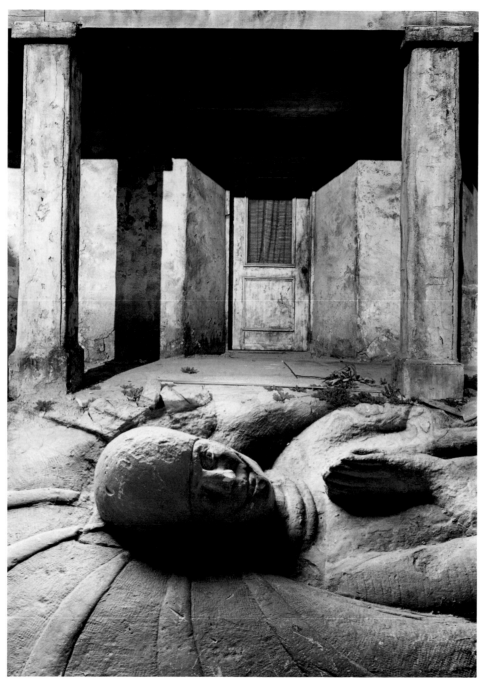

1985

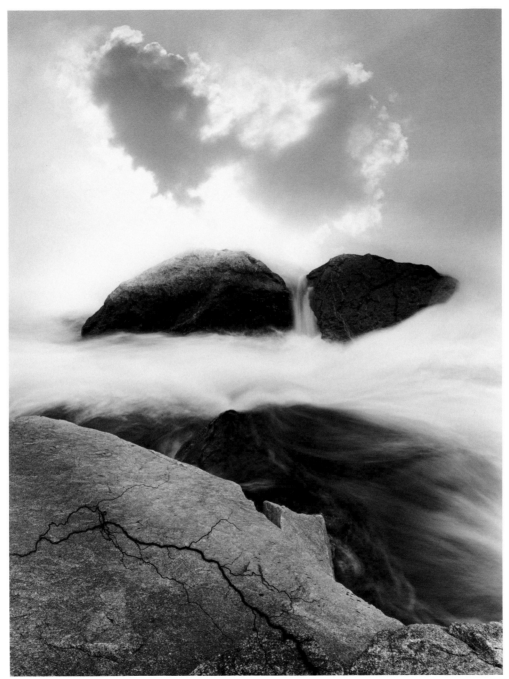

1985

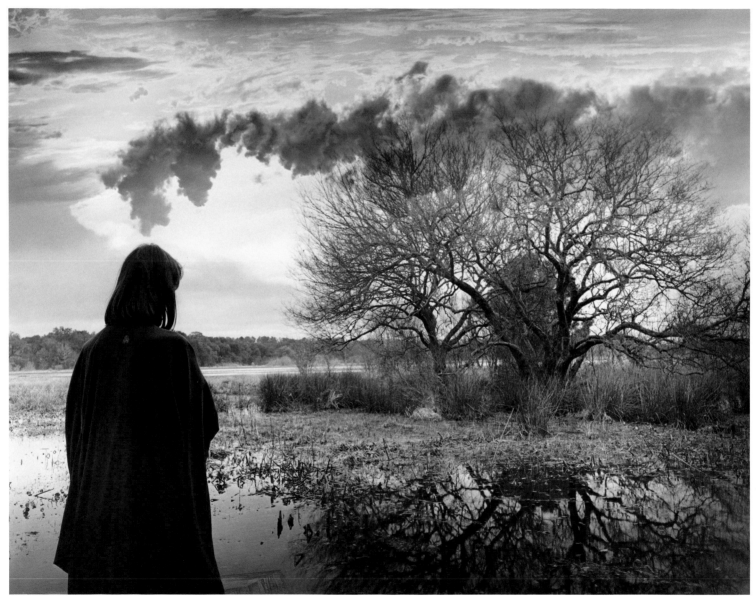

1985

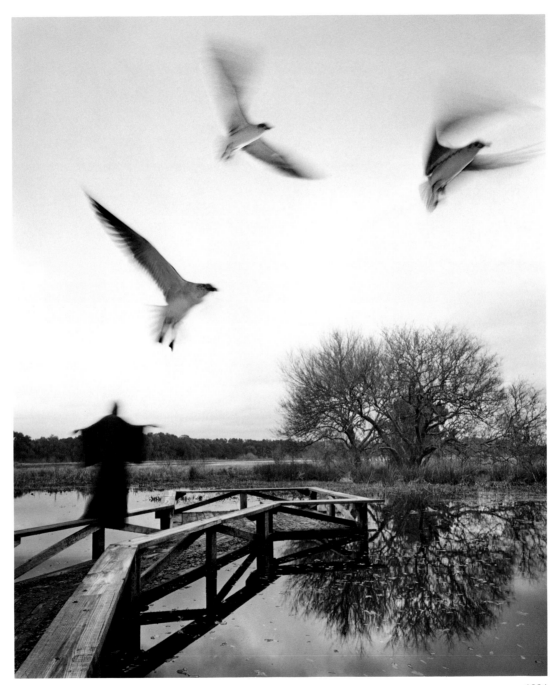

1984

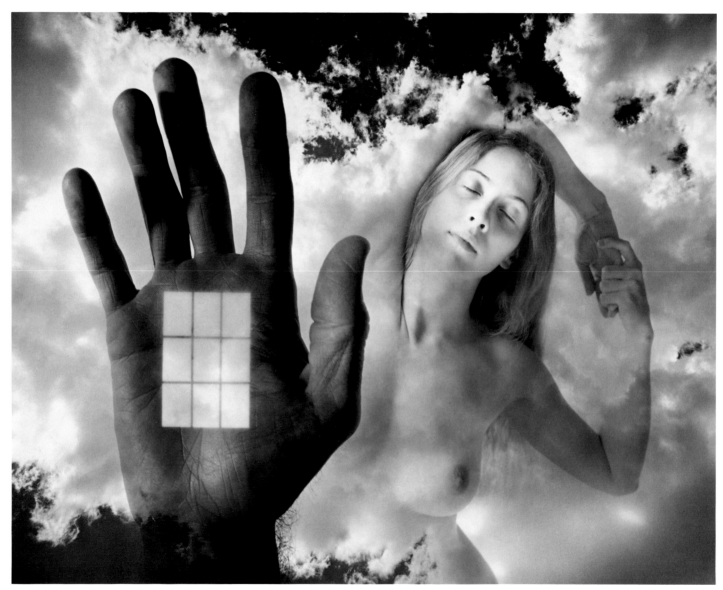

1981

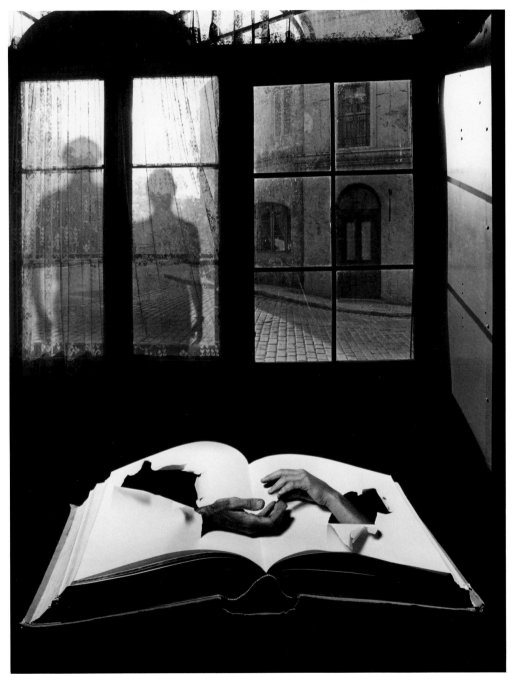

1982

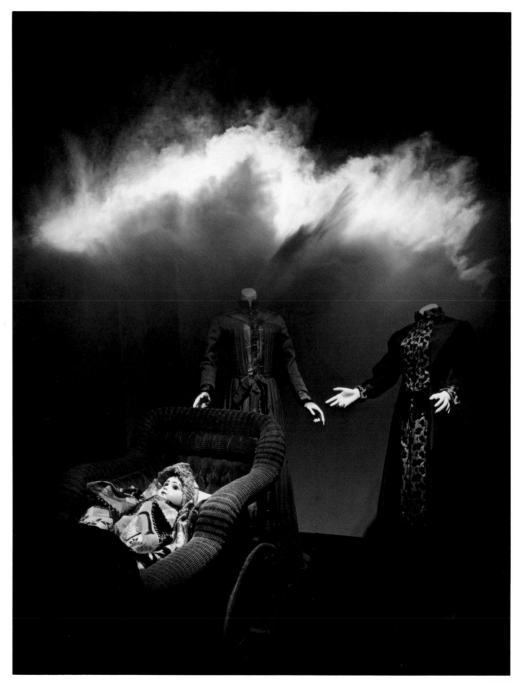

1985

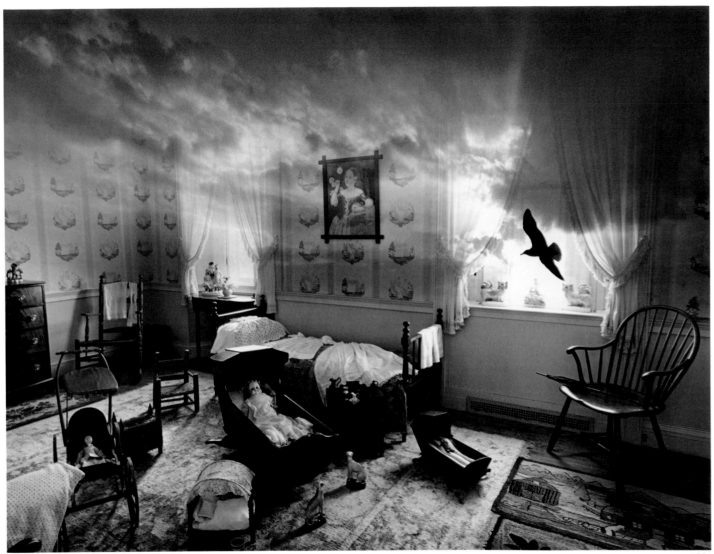

1981

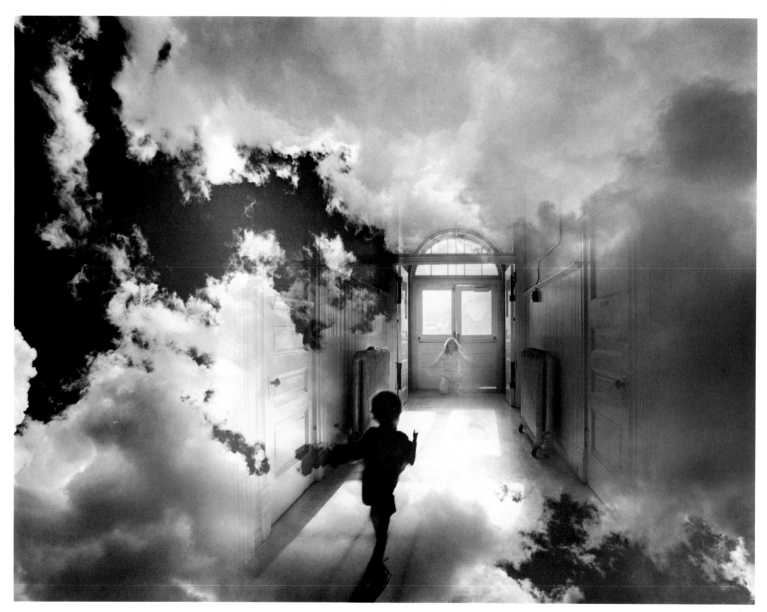

1981

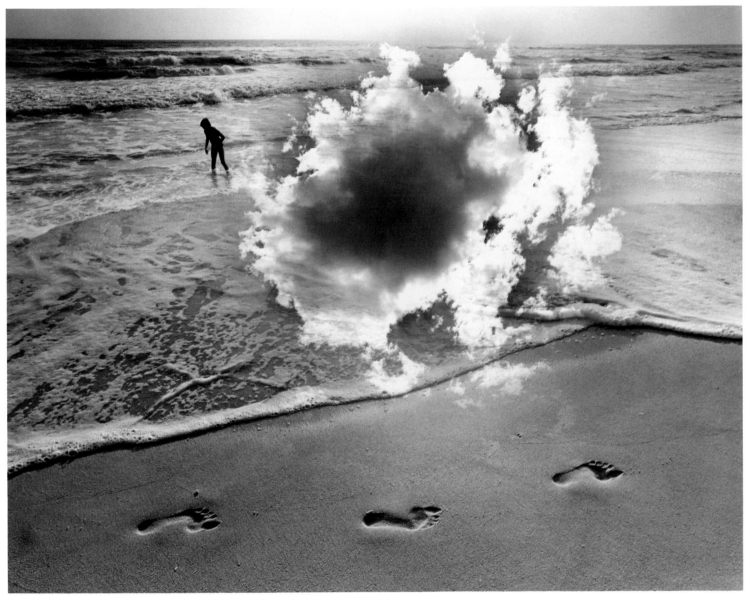

1984

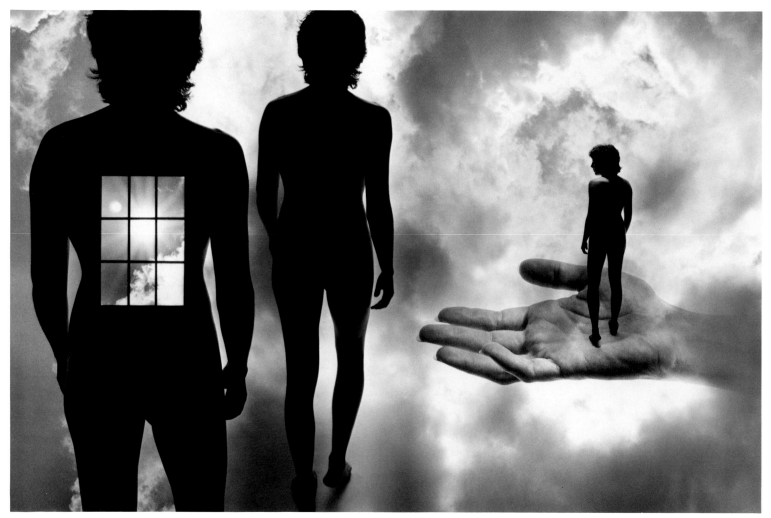

1985

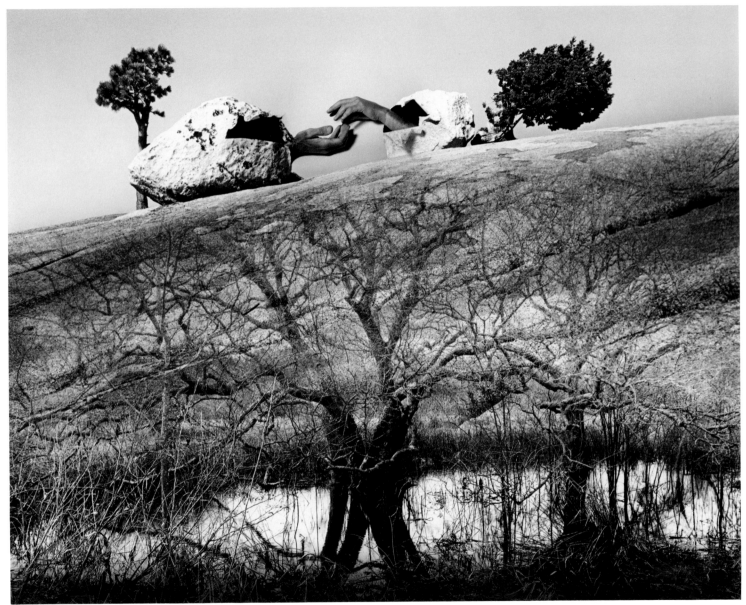

1985

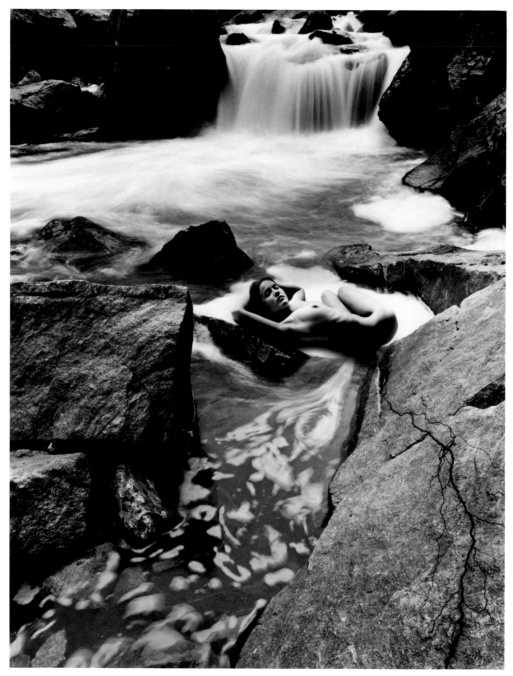

1985

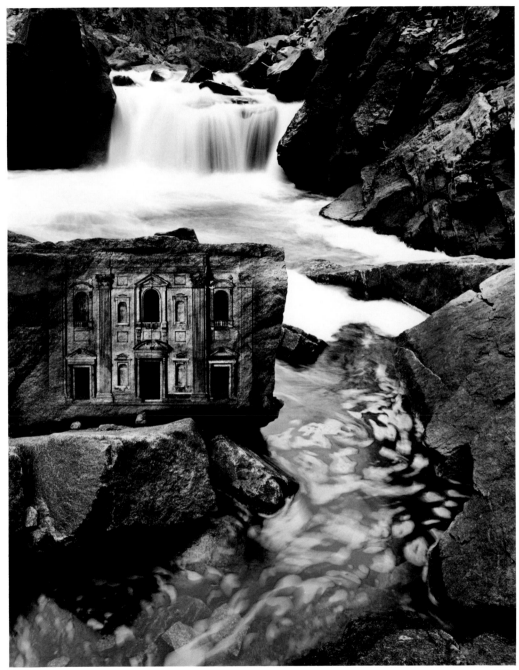

1985

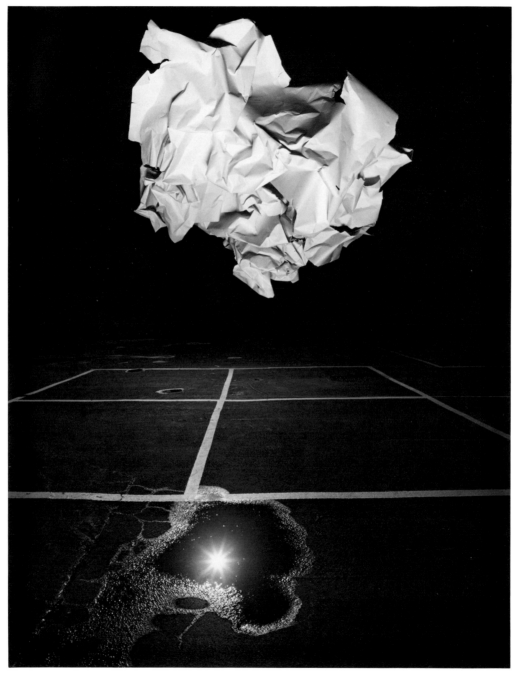

1983

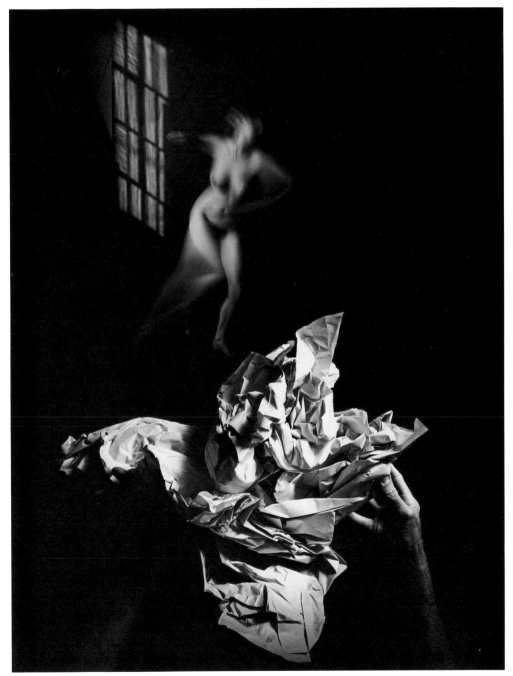

1983

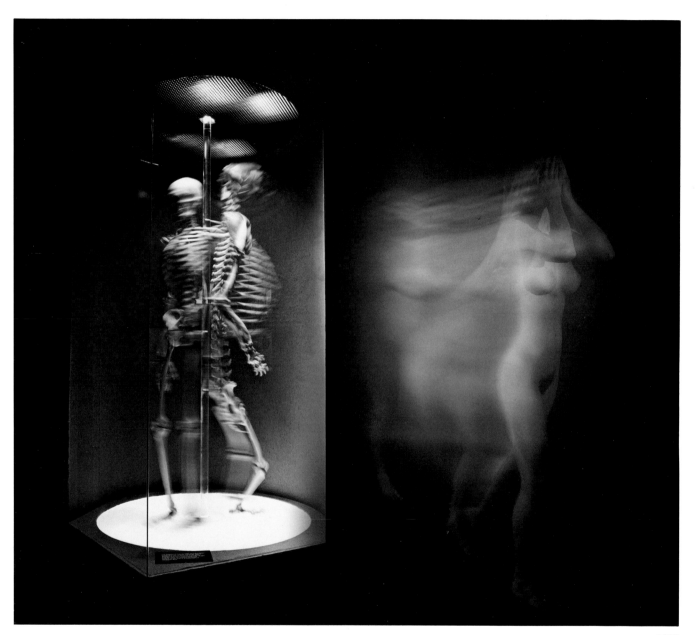

1980

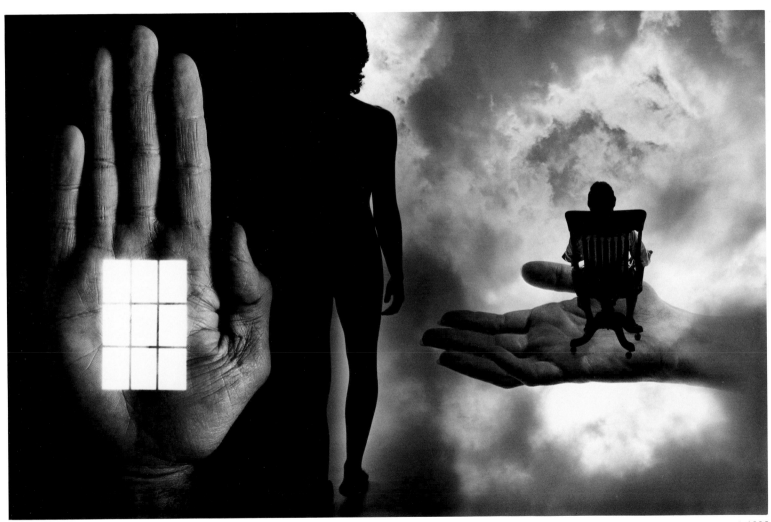

1985

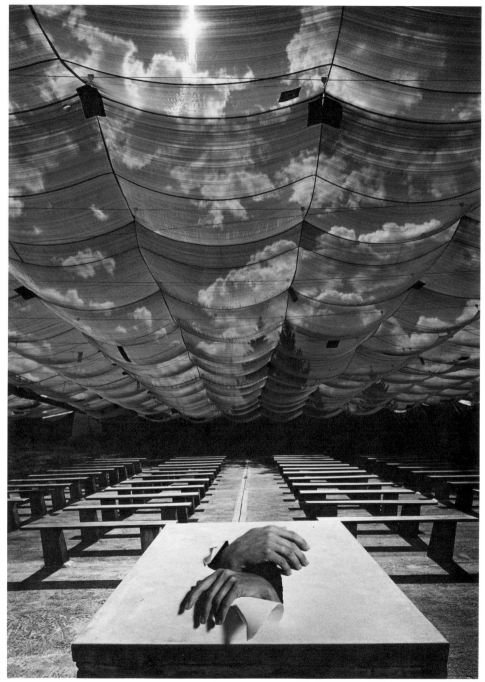

1982

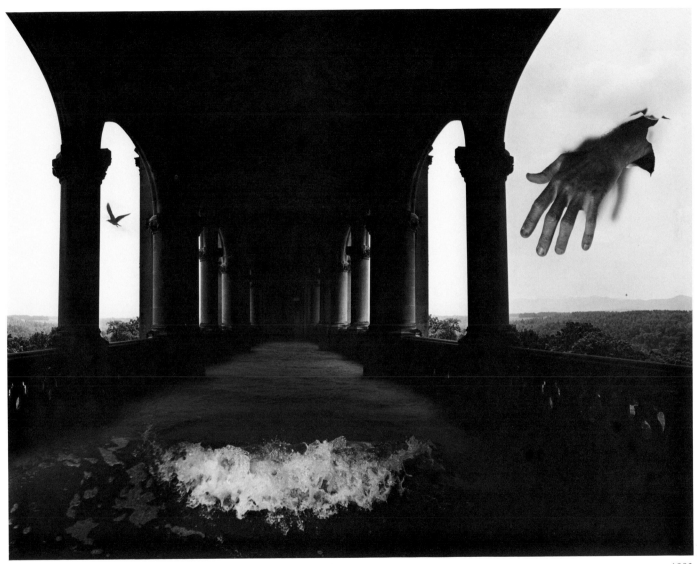

1982

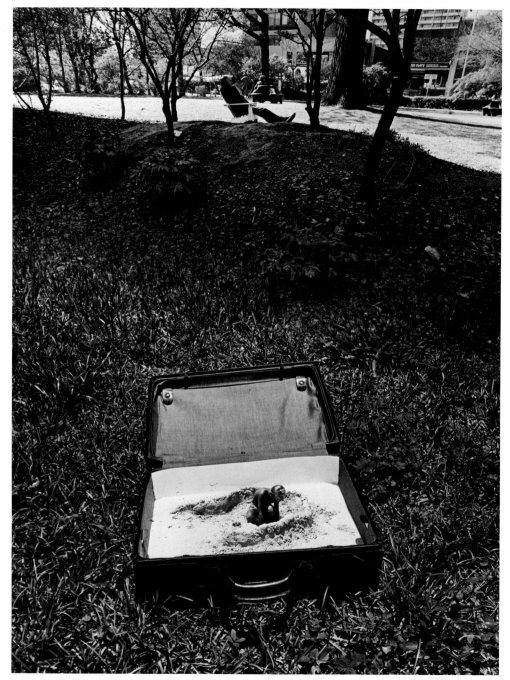

1982

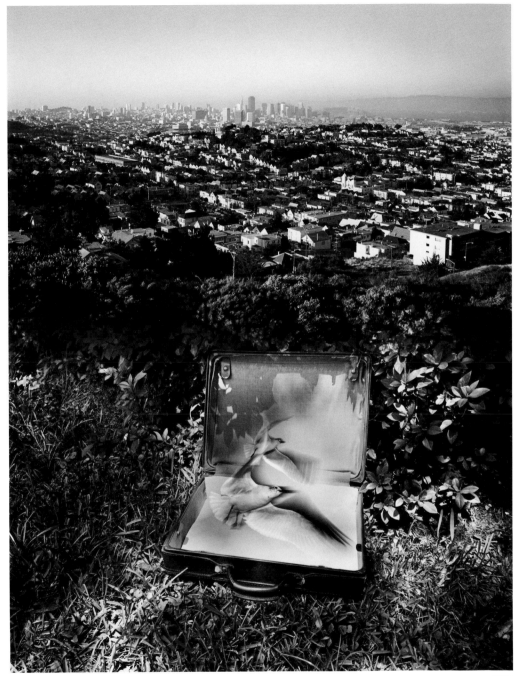

1984

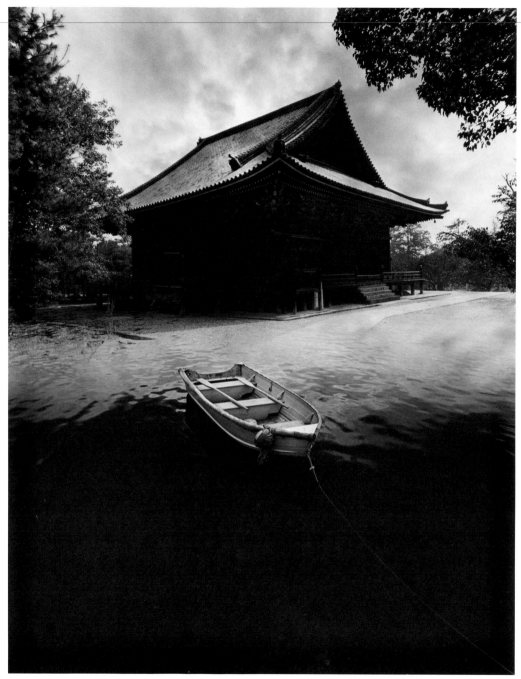

1981

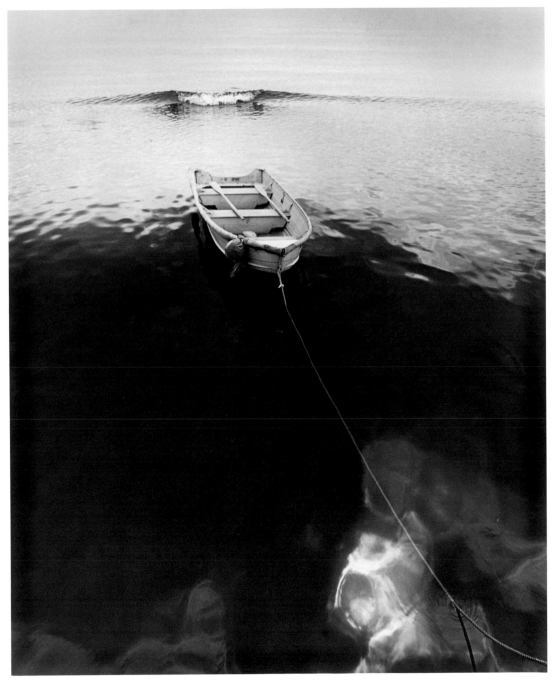

1983

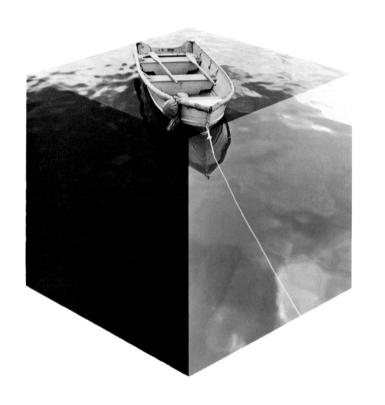 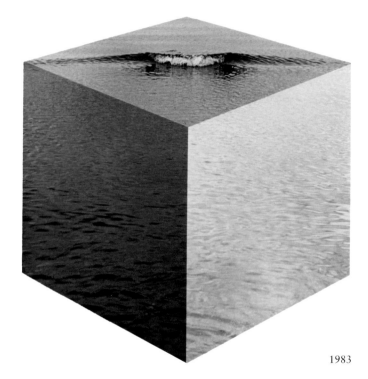

1983

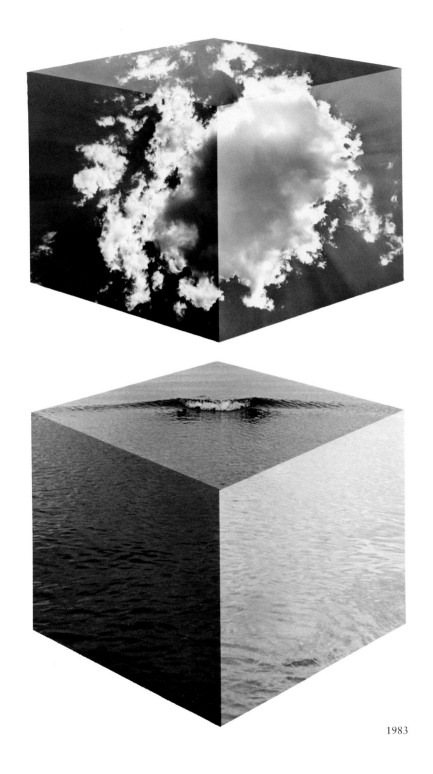

1983

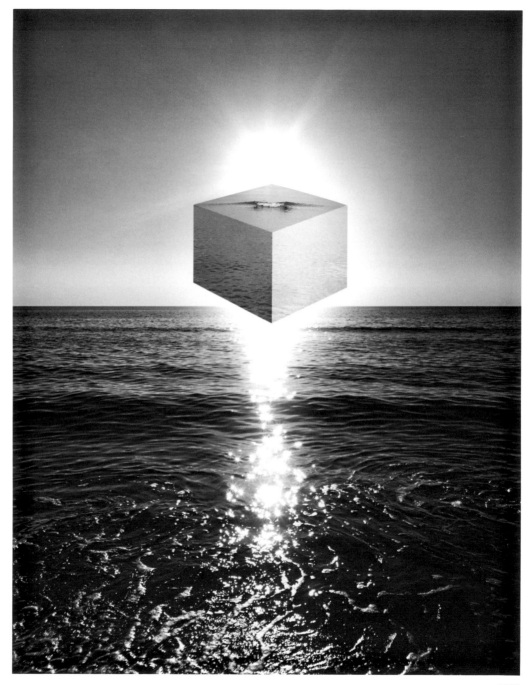

1983

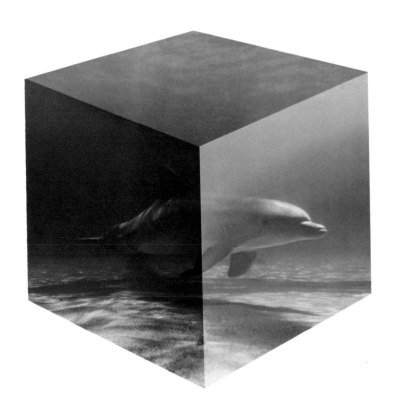 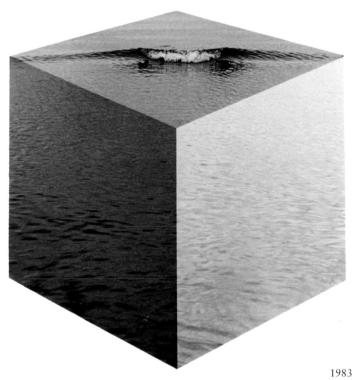

1983

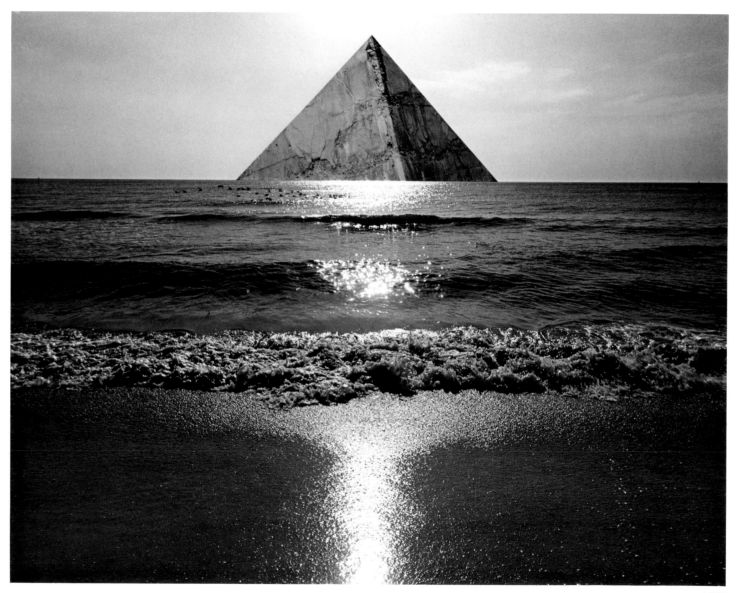

1980

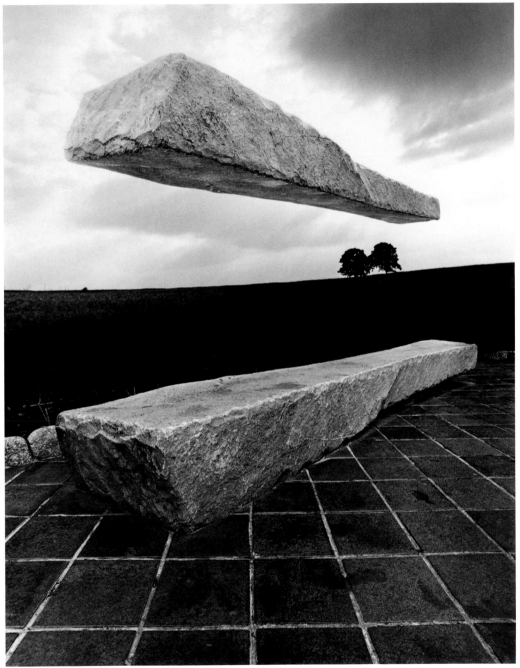

1980

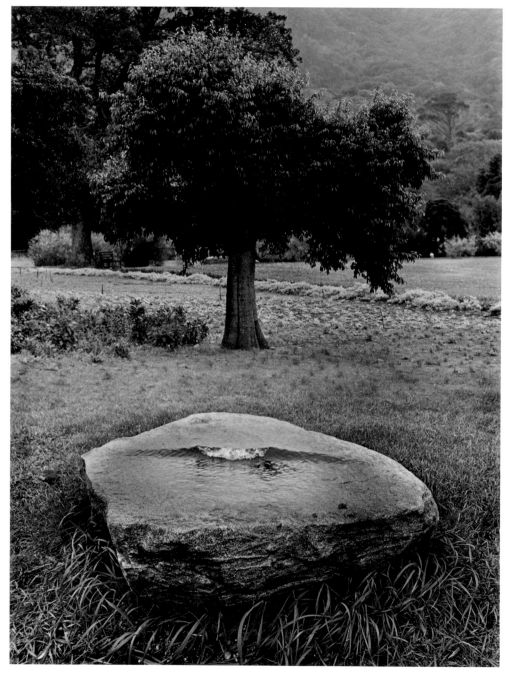

1982

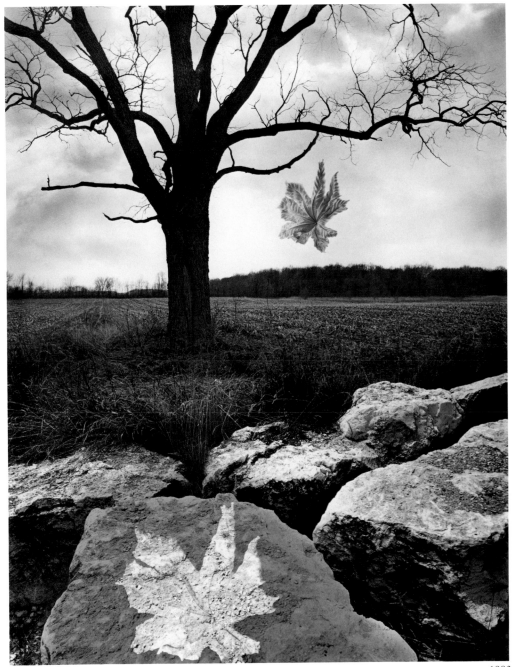

1983

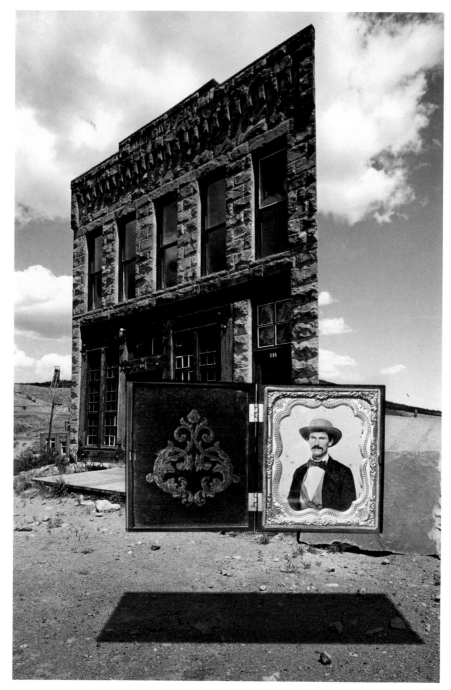

1980

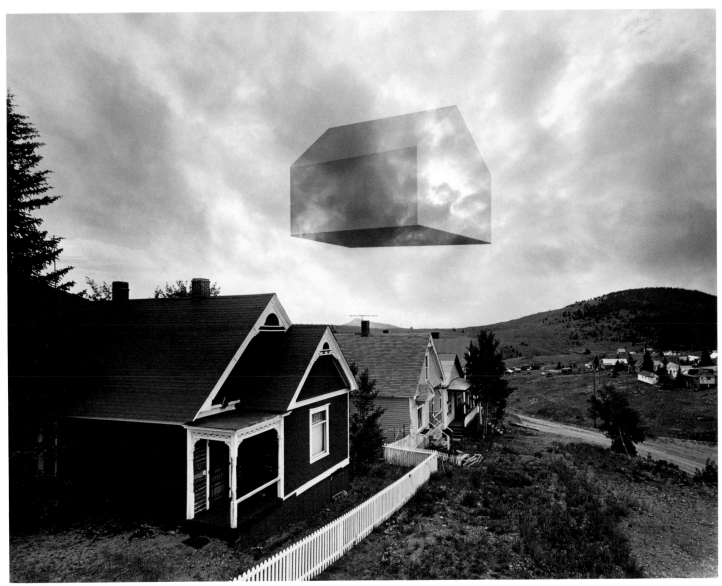

1980

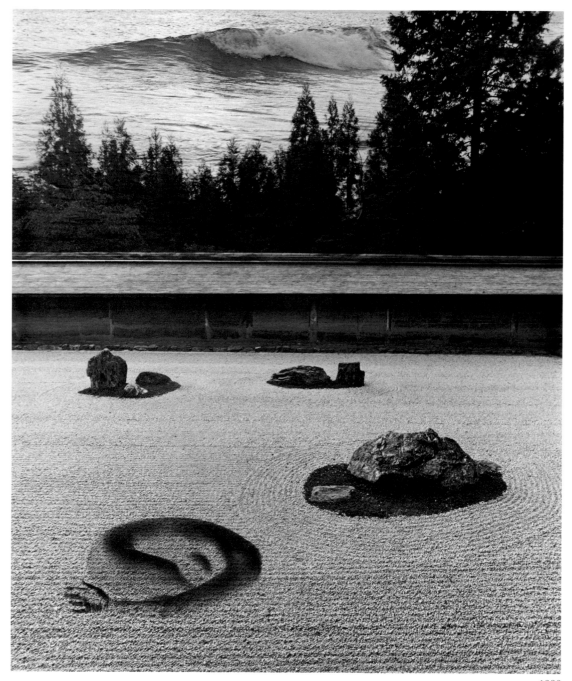

1980

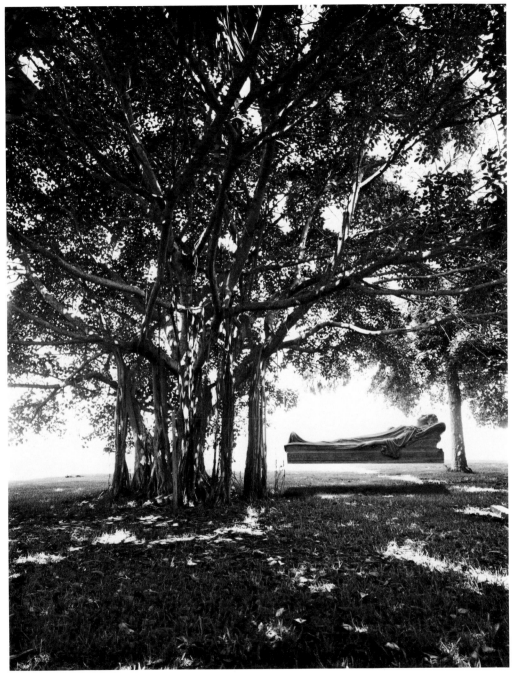

1980

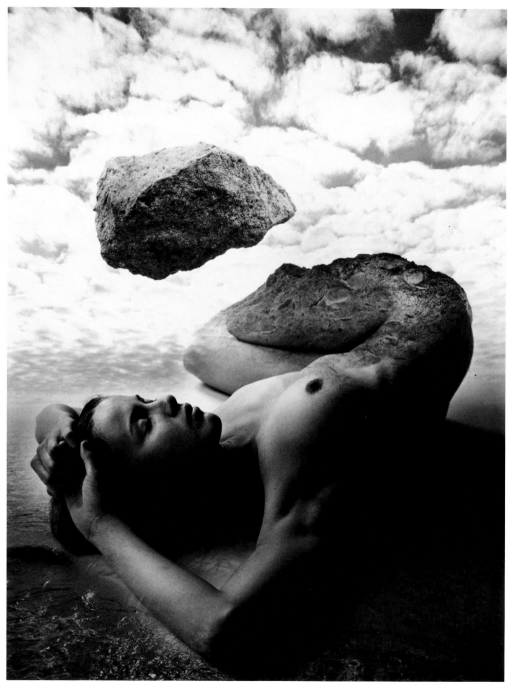

1982

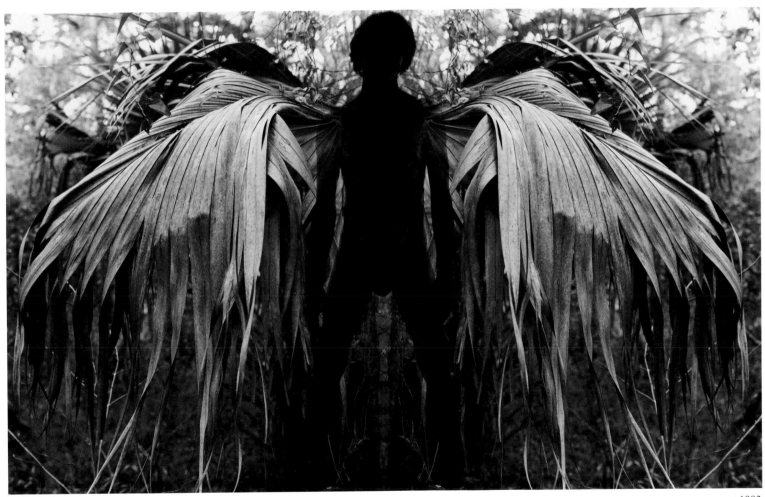

1982

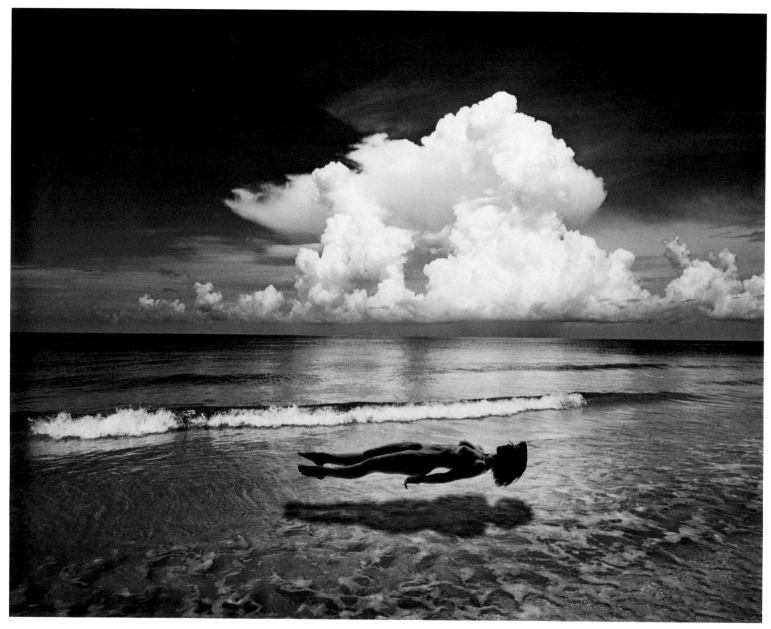

1986

1986

1987